SCREAM

DRAW CLASSIC VAMPIRES, WEREWOLVES, ZOMBIES, MONSTERS AND MORE

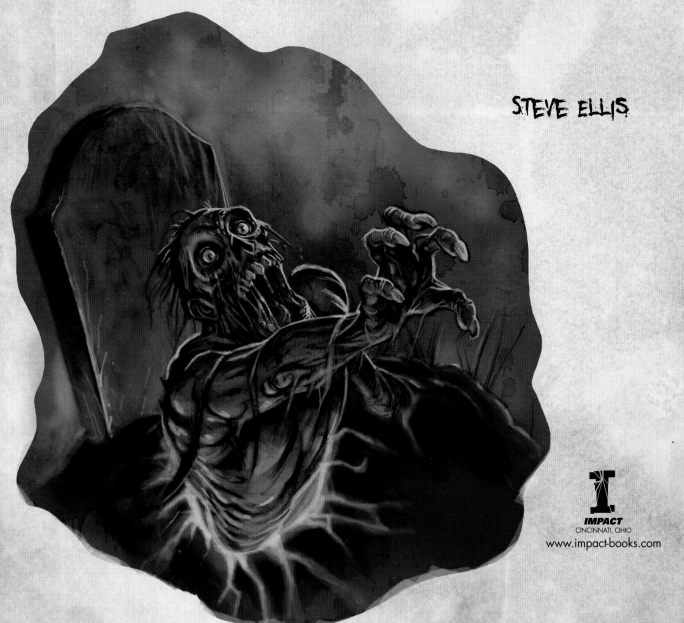

STEVE ELLIS

IMPACT
CINCINNATI, OHIO
www.impact-books.com

ABOUT THE AUTHOR

A graduate of the Syracuse University College of Visual and Performing Arts, award-winning artist Steve Ellis began his career as a penciller for both Marvel and DC Comics, where he illustrated iconic titles such as *Iron Man*, *Green Lantern* and *Lobo*. He then began to illustrate for *Dungeons & Dragons*, *Magic: The Gathering* and *Spectrum*.

Recently, along with author David Gallaher, Steve co-created the critically acclaimed werewolf-western webcomic, *High Moon*, for DC Comics' Zuda.

Steve is honored to have contributed work to the most recent incarnation of Michael Moorcock's *Elric* series, drawing his influence from Gustav Doré, Joseph Clement Cole and Bernie Wrightson.

Aside from hundreds of publications, Steve's painted work has hung in galleries alongside artists such as Shepard Fairey, Glenn Barr, Mitch O'Connell, Shag and Molly Crabapple.

After several years of teaching illustration and drawing at the university he once attended, Steve moved to Brooklyn, where he now lives with his wife and son.

See more of Steve's artwork at www.hypersteve.com. Read *High Moon* at www.highmooncomic.com or www.zudacomics.com/high-moon.

Scream: Draw Classic Vampires, Werewolves, Zombies, Monsters and More. Copyright © 2009 by Steve Ellis. Manufactured in China. All rights reserved. No part of this book may be reproduced in any form or by any electronic or mechanical means including information storage and retrieval systems without permission in writing from the publisher, except by a reviewer who may quote brief passages in a review. Published by IMPACT Books, an imprint of F+W Media, Inc., 4700 East Galbraith Road, Cincinnati, Ohio, 45236. (800) 289-0963. First Edition.

Other fine IMPACT Books are available from your local bookstore, art supply store or online. Also visit our website at www.fwmedia.com.

13 12 11 10 09 5 4 3 2 1

DISTRIBUTED IN CANADA BY FRASER DIRECT
100 Armstrong Avenue
Georgetown, ON, Canada L7G 5S4
Tel: (905) 877-4411

DISTRIBUTED IN THE U.K. AND EUROPE BY DAVID & CHARLES
Brunel House, Newton Abbot, Devon, TQ12 4PU, England
Tel: (+44) 1626 323200, Fax: (+44) 1626 323319
Email: postmaster@davidandcharles.co.uk

DISTRIBUTED IN AUSTRALIA BY CAPRICORN LINK
P.O. Box 704, S. Windsor NSW, 2756 Australia
Tel: (02) 4577-3555

Library of Congress Cataloging-in-Publication Data
Ellis, Steve (Steven A.)
 Scream : draw classic vampires, werewolves, zombies, monsters and more / by Steve Ellis. — 1st ed.
 p. cm.
 Includes index.
 ISBN 978-1-60061-179-7 (pbk. : alk. paper)
 1. Monsters in art. 2. Animals, Mythical, in art. 3. Drawing-Technique. I. Title. II. Title: Draw classic vampires, werewolves, zombies, monsters and more.
 NC825.M6E45 2009
 741.2–dc22
 2009013293

Edited by Mary Burzlaff Bostic
Designed by Guy Kelly
Production coordinated by Matt Wagner

Adobe and Photoshop are either registered trademarks or trademarks of Adobe Systems Incorporated in the United States and/or other countries.

Metric Conversion Chart		
To convert	to	multiply by
Inches	Centimeters	2.54
Centimeters	Inches	0.4
Feet	Centimeters	30.5
Centimeters	Feet	0.03
Yards	Meters	0.9
Meters	Yards	1.1

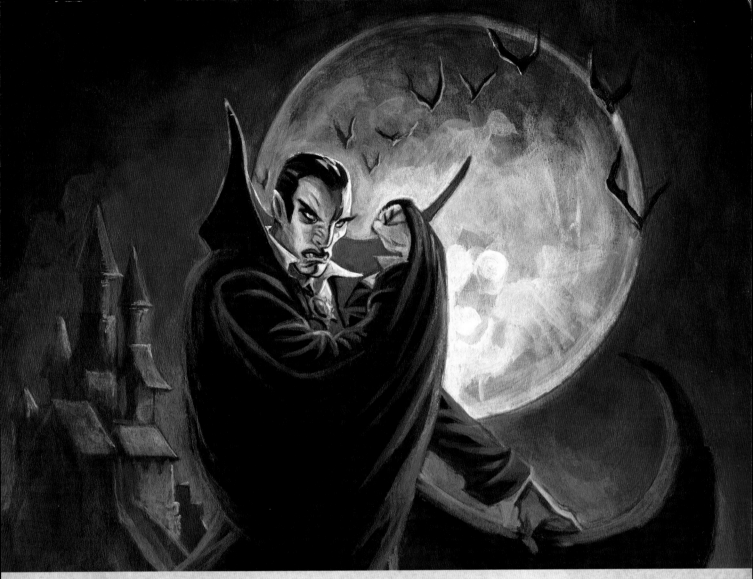

ACKNOWLEDGMENTS

To name all those whose foulness contributed to this monstrous tome would be a list too long to write. But first I would like to give my debt of gratitude to those great writers and artists of the past and present who have given life to the horrifying creatures of our imaginations. Edgar Allan Poe, Bram Stoker, Washington Irving, Mary Shelley, Bela Lugosi, Vincent Price, Ed Wood, Boris Karloff, Ray Harryhausen, Bernie Wrightson, Frank Frazetta and others too hideous to mention have influenced the creation of this book.

I would like to thank Harry B., Stew, Fred H., Fred V.L., David G., Jamal, Chuck, Dan G., Roger D., Bob D., Steve P. and Ben T. for helping me create better artwork or inspiring me with their stories and ideas and their friendship. I'd like to thank my parents for being OK with me studying art instead of architecture or something else practical. I'd like to thank Jenny and Drew for looking over my shoulder. Thanks to Mary, Guy, Pam and the whole IMPACT team for putting up with me and helping make this book fantastic. I'd especially like to thank Mila for all of her help, love, support and all of the late nights working and the late, late nights talking.

DEDICATION

This book is dedicated to my dad. He wasn't much for the monsters, creatures, comic books or movies, but he supported me and never gave up on me even when I'm sure he thought I was crazy. He may not be here anymore, but his strength, steadfastness and faith in the general good of things inspire me every day. Thanks, Dad, for being the "Rock."

TABLE OF CONTENTS

5 INTRODUCTION

CHAPTER ONE

6 TOOLS OF THE TRADE:
BASIC MATERIALS AND CONCEPTS

Drawing and Inking Supplies • Painting Supplies • Color Basics • Color Harmony and Temperature • Hue, Tone, Saturation and Pigment • Basic Shapes • Rendering and Lighting • Gesture Drawing • Anatomy • Parts is Parts! (Facial Features) • Monster Facial Features • Hands • Arms • Legs • Putting Down the Paint—My Process • Digital Coloring Process

CHAPTER TWO

32 VAMPIRES

Dracula • Vlad the Impaler • Dracula's Kiss • Nosferatu • Vampire Kid • Verdilak • Goth Vampire • Vampyra • Ripper, the Punk Vampire

CHAPTER THREE

66 MONSTERS

Jekyll and Hyde • Mary Shelley's Frankenstein • Frankenstein's Monster • Witch • Wolfman • Werewolf • Werebat • Swamp Creature

CHAPTER FOUR

100 THE UNDEAD

Zombie • Zombie Pirate • Mummy • Headless Horseman • Ghost • Ghoul

126 INDEX

INTRODUCTION

"Remember, I am not recording the vision of a madman. The sun does not more certainly shine in the heavens, than that which I now affirm is true. Some miracle might have produced it, yet the stages of the discovery were distinct and probable. After days and nights of incredible labour and fatigue, I succeeded in discovering the cause of generation and life; nay, more, I became myself capable of bestowing animation upon lifeless matter."

—*Frankenstein* by Mary Shelley

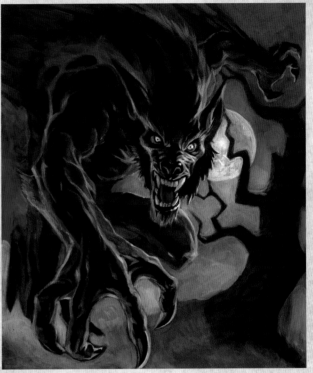

Welcome to the fine art of monster-making. Picking up this book indicates that you are intrigued by the same thing that Doctor Frankenstein was obsessed with: creating life.

You may not want to run around collecting body parts from graveyards to sew together, so you've chosen the much less messy path of drawing and painting. Your parents will thank you for not trying ol' Doc Frankenstein's techniques. Remind them of this when you drop a bottle of black ink on the white rug.

Within this book you'll find all manner of fiends, monsters and vile creations. These are the creatures that have haunted mankind's dreams for many years and continue to do so even today. I have produced a guidebook to give you the means to create monsters as fiendish as these and worse.

When you begin such an undertaking, you have to follow certain steps. You need tools, an understanding of techniques and, most importantly, your imagination.

How to Use This Book

This is a guidebook, with lessons and suggestions, not something you have to complete in order, monster by monster, until you have a book of your own that looks exactly like this one. After you've mastered the basic techniques, feel free to jump around. I've designed this book so that each demonstration has a different nugget of monster-creation information. You may even find that in true Frankenstein fashion, you'll want to piece two demonstrations together, looking at one demonstration for intensive pencil techniques and another for adding color. I've tried to show a bunch of styles, techniques, materials and suggestions for different processes so you can test which are best for you.

About the Digital Coloring Instructions in This Book

For my digital coloring, I use Adobe® Photoshop®; the instructions in this book refer to Photoshop tools and commands. However, many other image-editing software packages have similar tools and commands that accomplish the same or nearly the same effects. I make extensive use of layers, so if you want to do the digital coloring in my demos, you'll need a program with layers capability. Corel® Painter™ X, Corel® Painter™ Essentials, and Adobe® Photoshop® Elements are a few examples of paint programs with a layers feature. If price is a factor, check out the powerful freeware package GIMP (available from www.gimp.org).

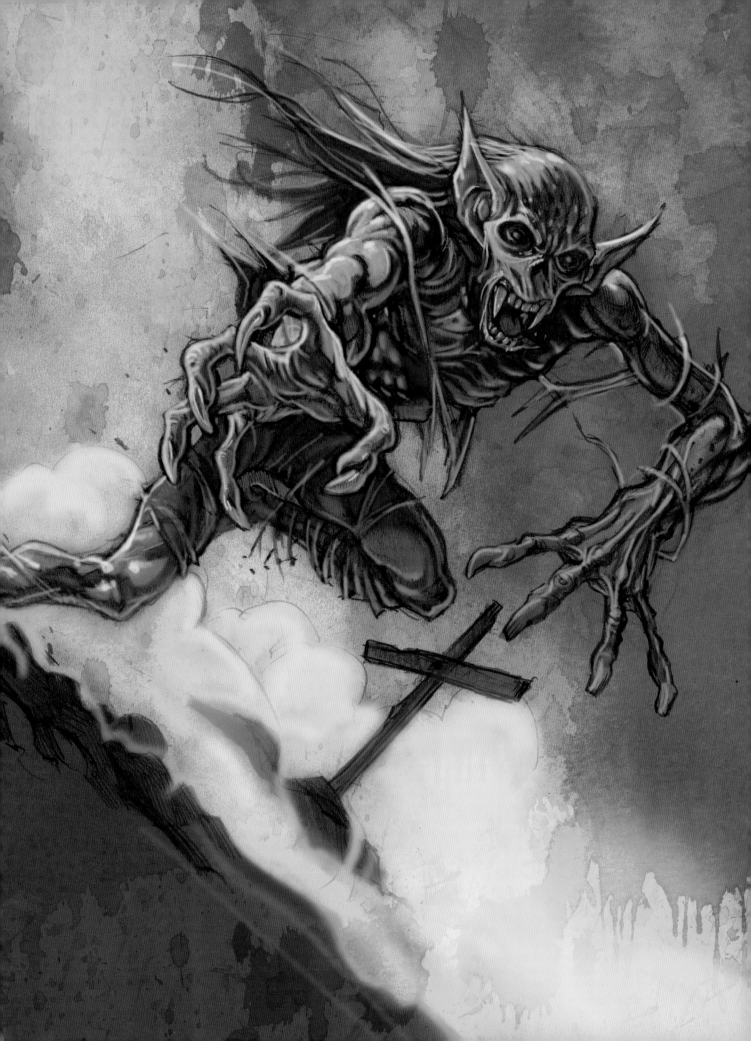

TOOLS OF THE TRADE:
BASIC MATERIALS AND CONCEPTS

BASICS? WHO CARES ABOUT BASICS? THE DEMON-STRATIONS HAVE STEP-BY-STEP INSTRUCTIONS, SO who needs this stuff? Skip right to the cool paintings and drawings.

That's what I would have done way back when I was buying drawing how-to books. I was always too impatient to go through all the basics. So here's a bit of advice: don't be like me. Take some time to go through these basics. At least familiarize yourself with the concepts. Later on, if you get stuck, you'll remember where to look for help. Here's a rundown of what I'll be covering in this chapter:

Supplies: You know that cliché about the starving artist. Well, the cliché is partly true because art supplies can get really expensive. The last thing you want to do is buy something you don't need or skimp on something that's vital. This section will help you figure out what's really important.

Color: You learned your colors when you were a little kid, right? But did your kindergarten teacher talk about saturation and hue? I didn't think so. Here's a chance to learn about color the way an artist thinks about color. Unless, of course, you don't mind your paintings looking like the work of a kindergartner.

Drawing: This section will teach you how to make your drawings really feel alive. You'll learn about creating volume through shading, making anatomy believable, then morphing that anatomy so that it becomes fantastical.

Painting: Whether you use paint and brushes or a computer, there are certain basic steps for laying down color. Think it doesn't really matter? Try putting down light colors before dark colors. You'll end up with a monstrous mess, and not in a good way.

So what are you waiting for? Start reading.

Drawing and Inking Supplies

Don't go overboard trying to get the "right" materials for the job. A good old no. 2 pencil was my favorite drawing tool long before I had any of these, and I still use them quite often. It all comes down to how much and how well you practice and study technique.

Drawing

I usually start by scribbling with a black roller pen and a marker for the big areas of black. After I've gotten my ideas down, I start in with pencil. I use a lead holder because it can be sharpened to a very sharp point, and the tip is wide enough to use its side for tones.

The lead depends on the paper. The rougher the paper, the more the lead smears, so use a harder lead (HB, H or 2H). HB is the softest of the three, and I use this all-purpose lead for layouts and underdrawings. For smoother paper, use B or 2B lead.

For a really dark drawing, I use a softer lead (6B is great), or I switch to black colored pencil, which has a nicer, richer color than lead. Sometimes I lay out the drawing with a light lead (H) and then move right to black colored pencil. That way, the underdrawing disappears under the darker colored pencil. It really depends on my mood that day.

Inking

I typically use a black acrylic ink by FW. I want ink that is waterproof, lightfast and really black. I'll explain what each of these qualities means below:

Waterproof ink won't smear with water after it's dried. Many inks promise this quality, but few really deliver, which is why I go with the acrylic ink.

Lightfast means the ink in your drawing won't fade when left in the light. I wouldn't leave your work in direct sunlight, but there's nothing worse than having the black areas of your artwork fade to gray.

I don't know how many times I've had the frustration of finding inks that are supposed to be black but are really gray, or a weird dark blue-green pretending to be black. If you need black, you need black.

I also use the Burnt Sienna and Antelope Brown inks from FW. After drawing, I often ink pictures with a 50/50 mixture of these two inks to avoid too many harsh blacks. I also use this brown mixture for washing over drawings. I can use them as finished images (sepia-toned images can look cool and aged), or I can paint over them using the ink wash as an underpainting.

Fixatives

Sealers and fixatives protect and seal your artwork. The last thing you want is for your pencil drawing to smear or your ink work to get ruined when you add paint on top. Fixatives and sealers add a necessary protective coat. Apply thin layers. A thick layer will ruin the surface of the paper. Crystal clear fixative creates a shiny coat of plastic and is fine if you plan to use acrylic or oil paint next, but pencils, some ink and watercolor will not adhere to it. Workable fixative will allow you to go back in with any medium. Follow the instructions on the spray can and follow the safety precautions.

DRAWING SUPPLIES

INKING SUPPLIES

INK

Painting Supplies

Acrylics aren't always the best solution, but they are versatile and give good results. I've tried oil paints, but they take a while to dry, and I like to work fast.

It's important to invest in quality acrylic paints. Otherwise it can be like painting with rubber. I prefer Golden Acrylics (I use both Heavy Body and Fluid). These have a buttery consistency and a lot of pigment (color), so the colors are rich even when diluted for washes.

I typically start with thin washes and build up to painting with thick, buttery paint at the end. This is the traditional approach for both oil and acrylic painting.

Paints

I like to use a range of colors. You don't have to buy all of the paints below, but you really need a warm and a cool version of each color (i.e., a warm blue and a cool blue, a warm red and a cool red, etc.).

Browns: I like Burnt Umber (warm brown), Raw Umber (cooler, greener brown) and Burnt Sienna (transparent, warm reddish brown). I also use Mars Yellow (brownish orange) and Raw Sienna (yellow-brown) on occasion.

Reds: I use Cadmium Red Light (bright, orangey red), Cadmium Red Medium (a more traditional red) and Cadmium Red Deep (dark, cool red).

Greens: I use Light Green (Yellow Shade) (bright green) and Hooker's Green (dark blue-green). I might pull out the Phthalo Green (Blue Shade or Yellow Shade) for a wash, but Phthalos are really powerful colors and shouldn't be used too much. Cobalt Turquois and Phthalo Turquois can be fun extras.

Blues: Ultramarine Light is opaque and fun to use. Primary Cyan, Cobalt Blue and Ultramarine are good for deeper purple-blue. I also use the Phthalo Blues (Red and Green Shades).

Yellows: I use mostly Cadmium Yellow Medium and Deep.

Purples: My favorites are Dioxazine Purple (an all-purpose dark purple for glazing) and Medium Violet (reddish purple). I use Light Violet, too.

Oranges: I use C.P. Cadmium Orange for a nice opaque orange.

Other colors: I use Naples Yellow and Titanium Buff for skin tones. Titanium White is a bright, opaque white. I use Bone Black occasionally, and Payne's Gray is another wonder color I use in almost every piece.

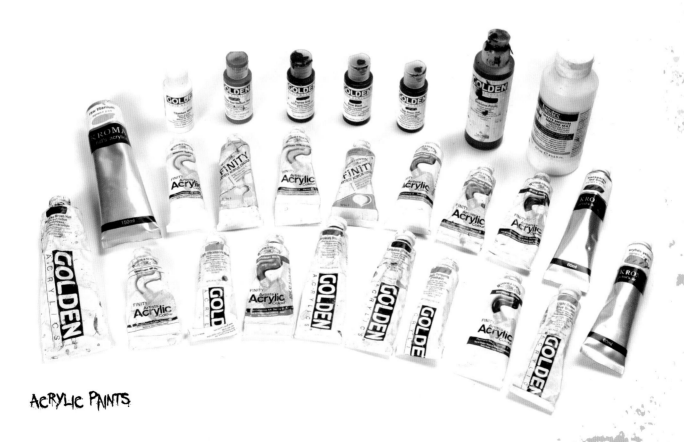

ACRYLIC PAINTS

Brushes

Don't go too cheap on brushes. That's not to say you have to buy the store, but a lot of cheap brushes will leave hairs in your paintings. There are some moderately priced brushes that will do the trick.

To start, you need a nice no. 3–5 (the number is the sizing) round brush with a pointy teardrop shape. After that, you'll need a bunch of inexpensive no. 1 round brushes for quick brushing. (Cheap no. 1 rounds have so few hairs, they rarely leave any on your paintings, so it's OK to save money on these brushes.) You'll also need some larger flat brushes for painting larger areas. Look for brushes with wide flat tops. A no. 5 and a no. 10 flat should be sufficient.

When looking for a pointy watercolor brush, ask the store owner for a cup of water to test the brush. Swirl the brush in the water, then take it out and flick your wrist holding the end of the brush handle. If the brush retains its shape, you've got a good brush.

Always wash your brushes after using them. If the painting is taking a long time, you might want to wash them out while you're still working. Acrylic paint can get deep into the hairs, attaching itself and causing the hairs to spread apart, which will ultimately ruin the brush. Always have a bar of soap dedicated to your brushes (any bar soap will do). Get them wet, get the soap wet, run the brushes along the soap to get some on the hairs, then rinse out the soap. You don't have to be too gentle, but don't pull the hairs out. After they're clean, use a tiny bit of hair conditioner on them.

Surfaces

I first work out my rough ideas in a sketchbook. Then, I usually do a more refined drawing on drawing vellum. This surface is transparent, so you can sketch loosely on one sheet, then lay another sheet on top and still see the first drawing so that you can do a more refined drawing on the top sheet.

For refined pencil and ink drawings, I use 2- or 3-ply bristol paper with a slightly rough or "vellum" surface. I use heavier, 3- to 5-ply bristol for painting with acrylic.

Palettes

I use a butcher's tray with three layers of cheap paper towels (the expensive ones absorb the paint). I spray the paper towels with water periodically to keep the paint and towels damp. This keeps the paint from drying too quickly on the palette. I lay my colors out from warms to cools to white and black.

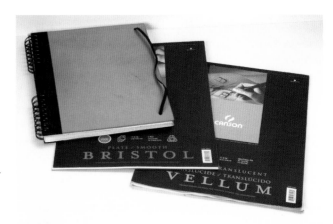

SURFACES

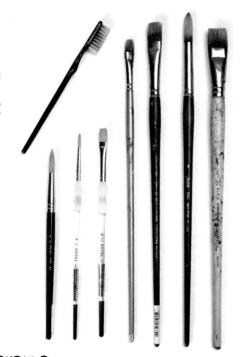

BRUSHES

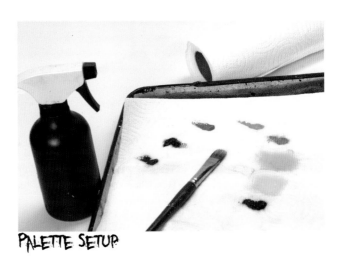

PALETTE SETUP

Color Basics

Monsters are more effective in living, breathing color. Even though we often see them emerging from the darkness, it's the vibrant, vicious color that brings them to life. Take a look at this section to figure out how best to use your colors to bring your monsters to life.

Red, Blue and Yellow (aka Primary Colors)

Technically, you can't use other colors to create primary colors. The fun part is that paint companies don't use simple names like "red," "blue" or "yellow" (they use fancier names like "Alizarin Crimson"), so you have to do a little guessing. Try to find paints that approximate the basic primary colors.

Secondary Colors

These are the colors immediately mixable using only the primary colors. Green is made with yellow and blue, orange with red and yellow, and purple with red and blue.

Tertiary Colors

Tertiary colors are mixed using the primaries and the secondaries. These colors include yellow-orange, red-orange, red-purple, blue-purple, blue-green and yellow-green. Tertiary colors are used more frequently than primaries. Tertiaries expand the range of color available to the artist and allow a greater opportunity for subtlety in the work.

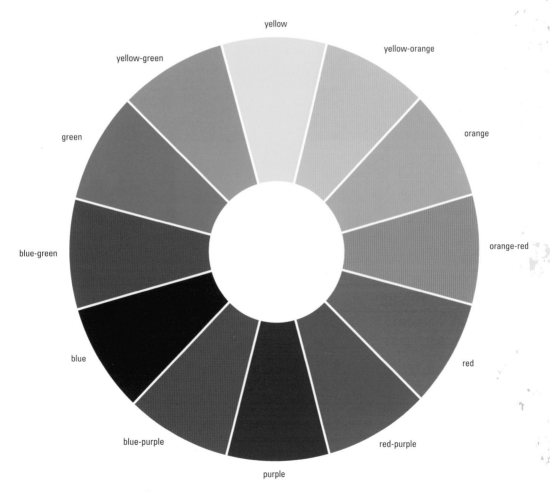

12-COLOR WHEEL

On this basic color wheel, you can see all the primary, secondary and tertiary colors.

Color Harmony and Temperature

Harmony is a funny word. We usually apply it to music, describing the sounds from different instruments and people working together to make a new beautiful sound. None of the original sounds disappear, and you could pick each one out. But, together, they create a beautiful whole. Similarly, colors can work together (next to each other, not mixed) to create beautiful harmonies. Read on for more about the two most common types of color harmony: analogous color and complementary color.

Analogous Color

Technically, this is using any three colors that are next to each other on the twelve-part color wheel. Yellow, yellow-green and green are one example of analogous color harmony.

Complementary Color

Complementary colors can be used to create another type of color harmony. Complementary colors are those on opposite sides of the color wheel (red and green, red-purple and yellow-green, blue and orange, yellow-orange and blue-purple and so on…).

Warm and Cool Colors

Wait a minute, color can be hot or cold? Not exactly, but color can give you the sense of coolness or warmth. A warm color is any color that has more of a yellow cast to it. Those colors on the yellow side of the color wheel (oranges, browns, reds, yellow-greens, etc.) are the warmer colors.

Cool colors are based on blues, including greens, pinks, purples, blue-greens, magentas and blue-based reds.

If you have a blue with a touch of yellow in it (making it approach green on the color wheel), it is a "warm" blue. If you take a yellow and add a bit of blue, making it approach green, it will be a "cool" yellow. Reds tend to go both ways very easily; a red with a blue tinge has a "cool" purple effect, whereas red with a yellow tinge approaches a "warm" orange.

When you're painting, think about where the monster is. If he's crawling out of a dark, dismal, firelit cave into the cool moonlit forest, warmer colors should be coming out of the firelit cave and cooler colors should be in the moonlit areas. In general, use warm colors for daytime and cool colors for nighttime.

ANALOGOUS COLORS

Analogous colors blend together nicely and create a soothing transition.

COMPLEMENTARY COLORS

Complements form nice contrasts and work against each other, creating exciting visual effects.

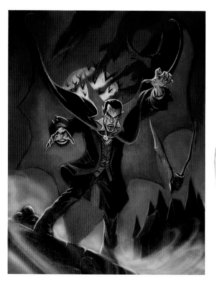

WARM AND COOL LIGHTING

Here, the moon, the background and the lighting on the top of the figure are all cool in color, while the figure's underlighting is warm. In more "normal" lighting situations, the light is warm and the shadows are cool.

Color Experiments

Put different colors next to each other. How do they affect one another? If you put a blue next to a red, and then a green next to the same red, does the red look different?

Hue, Tone, Saturation and Pigment

Hue

Hue is a fancy word to say which color you're using. Red is a hue. Blue can have a "reddish hue," which means it has a little red in it. No biggie.

Tone (Value)

Tone or value is a way of describing how dark or light a color is. A darker toned red tends to have more black in it, and a lighter toned red has more white in it. As long as you have the tones in your painting right, the hues almost don't matter. Hue is like the dressing on a good tonal painting. Old Masters sometimes completed entire paintings in gray tones before adding color to ensure that the tone balance was right.

Create a tonal scale from white to black at ten-percent intervals, making a range of grays (see below). Then create the same range with a color.

Saturation

Saturation is the amount of color you are using. Technically, in paint, it is the amount of pigment that is being applied. Blue right out of the tube is considered full-saturation blue. If you water down the color, it gets thinner, and you can see through it more. This is a low saturation of the color. The paint is spread thinly over a wide area and doesn't have the full punch of the more saturated color.

Pigment

Technically, a pigment is the material in paint that gives it its color. In Ultramarine Blue, for example, the pigment is a substance called ultramarine, which has been ground and mixed with a binder (the gooey substance used to keep the pigment powder together). The amount of pigment in a paint correlates directly with the color intensity or saturation.

VALUE SCALE

A tonal scale is essentially a smear of pencil that goes from really dark to really light. Make one so you get used to using your pencil to create tones from light to dark. Try holding your pencil at different angles and make different types of marks to create your tones.

COLOR VALUE SCALE

Start with the original color in the middle, then add black at intervals to create darker shades, and add white to create lighter tints.

SATURATION COMPARISON

Here you can see a high-saturation red (left) and a low-saturation red (right).

Basic Shapes

I'm sure you're saying, "Steve, I don't want to draw all of this boring, normal stuff. I got this book to draw scary monsters!" Well, if you want to draw monsters that scare the daylights out of your mom, you have to make them convincing.

Convincing means that the eye falling from the socket of that zombie looks like a real eye. Those guts on the floor of the mad scientist's lab need to look like real guts to get your best friend to say "Gross!" Learn as much as you can from the following exercises so your creations can come to life.

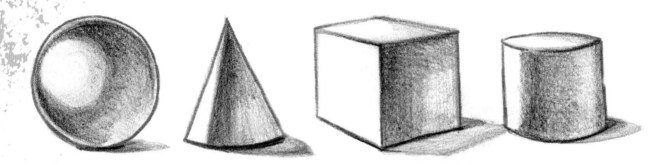

SIMPLE SHAPES
These basic shapes are the building blocks of everything: circle (or sphere), triangle (or cone), square (or cube) and the all-purpose cylinder. Without them you can't begin to draw a monster … or anything. Look at a car, for example. It's essentially a small box, sitting on a big box, resting on four stubby cylinders laying on their sides. If you can visualize those shapes when you start drawing the car, it makes your life as an artist a whole lot easier.

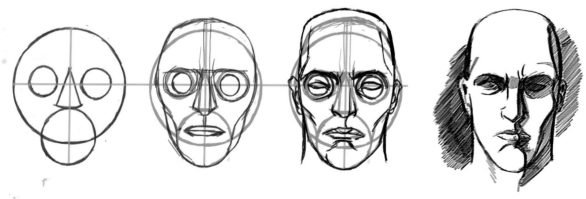

BASIC SHAPES CAN BE USED TO BUILD ANYTHING
Practice putting basic shapes together to make different things. As you can see on the next page, more complex combinations of these objects can help you visualize almost anything you want to draw. These shapes are guidelines for the more complex drawing you will do later.

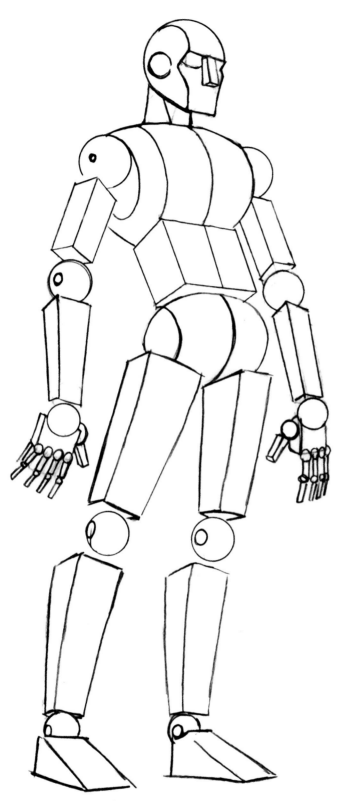

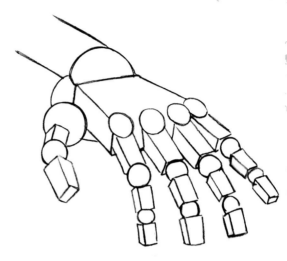

HAND CONSTRUCTION

Use a flat box for the body of the hand with balls for the knuckles. Don't use tubes for the fingers! This will make them look like little sausages hanging from the hands. Fingers have a very solid structure created by the bones and muscles under the surface. Use boxes to form the separate joints.

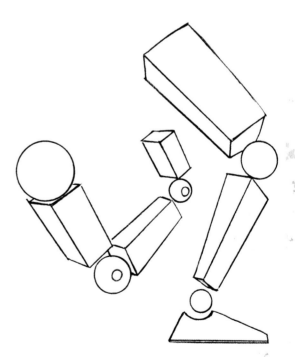

BUILD A BODY

When constructing a human figure, imagine you are building a robot with hard cubish parts, roundish tubular parts and circular parts. Building your figures like this can help you imagine shading, lighting and the structure of the figure.

I use more square shapes for the bigger forms of the body, and ball shapes for the joints. Try different shapes.

JOINTS AND MOVEMENT

I use ball shapes for the joints to help me remember that when the arm or leg bends, the elbow and knee don't change. These shapes give me the freedom to twist and turn the arms and legs in many different positions.

Rendering and Lighting

How scary would Dracula be if he was standing in the sun on a beach? (Well, he'd be a pile of dust, but that's beside the point.) He wouldn't be very scary at all. The thing that makes him scary is that he's always standing in the shadows, lurking silently in the graveyard, watching your every step. But, if we drew Dracula in the darkness, that wouldn't be fun either. All we'd have is a big black sheet of paper. This is where lighting comes in handy. Used effectively, light can make a character appear to emerge from the darkness, ready to strike!

Before you can get involved with light, you have to be able to use your pencil to create shade.

SHADING AND TONES
Grab a pencil and hold it so the flat side of the pencil (not the point) is touching the paper. Now scribble from side to side. The more pressure you apply to the pencil, the darker the tone. Practice transitioning between the tones like you see in the box here.

Light Tip
When working on your monsters, consider sketching a little light bulb to represent the light source location, then draw lines coming out of it (you can do this lightly on your drawing or use a piece of tracing paper over the drawing). Any object that gets in the way of the light lines will cause everything behind it to be dimmer.

SHADING SPHERES
Look at the spheres surrounding the light bulb. Each is affected differently by the bulb because of its position in relation to the bulb. Each has a highlight, form shadow, reflected light and cast shadow. The highlight is the point where the light shines directly on the object; the form shadow is the area of shadow that flows over the form as it moves away from the highlight; the reflected light is the light that has bounced up from the surface the sphere is resting on, back onto the sphere; and the cast shadow is the shadow created by the sphere blocking light from reaching another object.

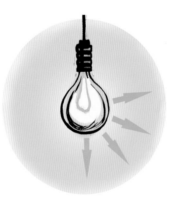

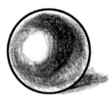

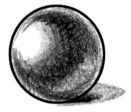

Light and Shadow

Remember, just like in the movies, there is a light side and a dark side. The light side is anything within effect of the main light source. The dark side is anything facing away from the main light source. There is still light in the dark side (reflected light to be exact), but, to quote a professor of mine, "Your lightest dark can never be the same as your darkest light." An easier way of saying that is, "No light on the dark side of the figure will ever be as light as the darkest area of the light side…"

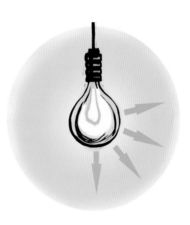

LIGHT RELATIONSHIPS AND FORM

The light bulb is the main light source on this sphere. The yellow arrow indicates the highlight. The red arrow points to the darkest area. It is the separation point between the light side of the sphere and the dark side. On the side facing away from the primary light source, the sphere reflects the colors from the rest of the world. In the shadow areas you will see the blue from the ground reflected in the dark areas of the ball (blue arrow). This relationship between primary and reflected lights forms the basis for creating 3-D shapes.

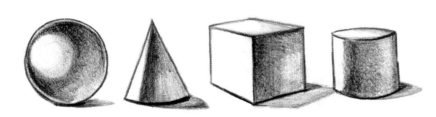

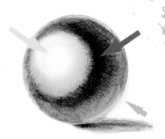

TRY DIFFERENT SHAPES

See how different shapes reflect light. They all react differently. Get some real objects to look at and sketch with a light source.

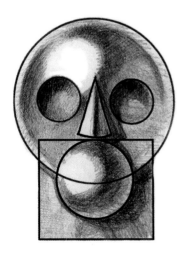

PUT THE SHAPES TOGETHER

Put basic shapes together to create a head, then shade the objects with the same light source.

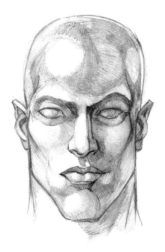

REFINE THE SHAPES

Now try a more refined drawing of a head. Remember the shading from the basic shapes. Voilà! You have a well-rounded head.

> ### Contrast Tip
>
> Use contrast to your advantage. For every light, there's a dark. Against the lightest light, there is always the darkest area of dark. For example, if there's a bright white glint in a monster's eye, there will be a corresponding dark right next to it.

Gesture Drawing

So you want to draw an evil demon from the third hell, but you don't exactly want him to look like he's standing around, waiting for a bus like some ordinary schmo! He should be wildly threatening you with his glistening teeth and razor sharp claws, right? This is where gesture drawing comes in.

Learning to get movement and excitement out of your gestures is an important step to creating scary monsters. An exciting, fluid gesture can help keep your drawing from becoming ornate and stiff with details. Keep your drawings loose, quick and scribbly at first. The action of your hand will transfer the excitement in your mind through the pencil and onto the paper.

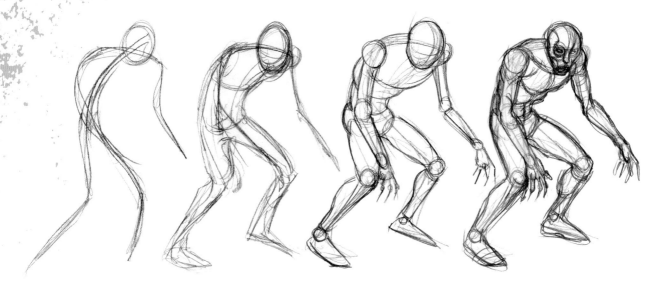

THINK, ACT IT OUT, THEN DRAW IT

Start a gesture drawing by thinking about the kind of emotion you want your monster to express. Is he mad? Frustrated? A little peeved? (Most monsters are pretty simple folk: their emotional states range from ticked off to blood-lusting rage.)

Now comes the acting part. Acting? Yeah, every good artist is at least part actor. Stand in front of a mirror and be the monster. Make faces and move your body to be fierce, angry, hurt, threatening, scared. Ham it up! Notice how the position of your shoulders, head, arms, legs and hips changes the emotion. Try drawing the gesture for each of those positions. Have fun! Get a friend to take pictures of each pose so you can refer to them later.

Draw a bunch of gesture drawings on sketching paper. This is not the time to be precious about every line. In fact, in my drawing classes I keep a stopwatch and won't let my students draw for more than 30 or 60 seconds.

Move your hand quickly across the page, keeping your drawing loose, and scribble the form of the creature. As you draw, try to scribble in the big forms such as the head, then the torso and the arms and legs. Eventually you'll have a skeleton to hang all of your details on. When you are starting out, it's especially important to use the circles, tubes and squares to provide the solid forms, then slowly add all the fun details for a creepy monster.

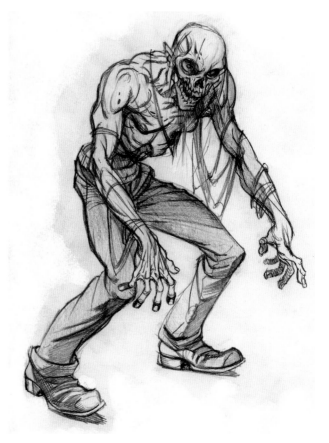

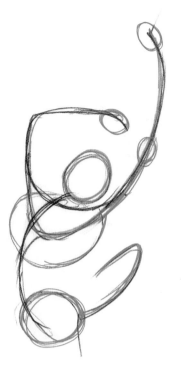

1 Start With a Gesture Drawing

Now try a werewolf gesture drawing. First draw a loose, arcing line from the head, around and down to the center of the hips. I call this the backbone line. It gives our raging friend backward thrust, which implies that he's really roaring. This line is usually the most important for the gesture. Play around with drawing all kinds of backbone lines to see how varying this line changes the werewolf's expression.

Next draw a line from shoulder to shoulder, and another line for the hips. These two lines, plus the backbone line, establish the feeling for the entire drawing. Next, draw in lines for the arms and the legs. After those lines are complete, scribble in the big forms like the head, torso and arms.

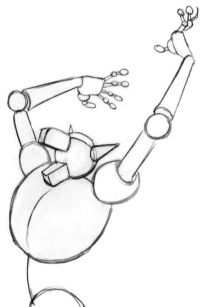

2 Construct the Figure

Build the shapes of the body off of the gesture sketch. Use your knowledge of basic shapes and anatomy to fill in where the torso, hips and head should be.

3 Add Details

Start hanging the details on the basic structure, like a skin over a frame. Add muscles, hair, eyes, nose and teeth. You've got yourself a werewolf!

Anatomy

After creating your gesture drawing, the next step is fleshing out your creation. Start putting meat on those bones! Look at the werewolf example on page 19 again. The second step is always to put the circles and tubes in place. Then start constructing the anatomy out of the gesture and getting the details in place. Look at the following examples and try to learn the positions of the eyes, ears, nose and mouth.

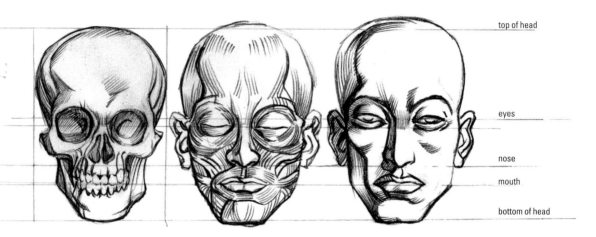

top of head

eyes

nose

mouth

bottom of head

FACIAL FEATURE PLACEMENT

The eyes on a normal person are approximately halfway from the top of the head to the chin. I know, I know, you're looking in the mirror thinking, "My eyes are much higher on my head than that. They're near the top." That's an optical illusion created by the fact that your hair is blocking the top portion of your head.

Now look at the nose. It ends approximately halfway between the eyes and the chin. And the mouth? You guessed it, about halfway between the bottom of the nose and the chin.

There's an imaginary line running down the center of your face. Each half is almost a mirror image of the other. We are bilateral creatures, meaning we have one eye on one side and one on the other, one arm on each side, etc. Even the lips are split in half.

Draw From Life

Following the exercises here won't replace drawing from life or getting a really excellent anatomy book such as those written by George Bridgman or Burne Hogarth. It takes years of practice to learn anatomy, so don't get discouraged if it doesn't work out the first time.

The Torso

The torso is bilateral and is split into three major masses from the neck to the crotch. These masses are designated by how they move separately from each other.

The chest area starts at the base of the throat and ends at the bottom of the rib cage. The rib cage is solid to protect the organs but can be moved by muscles.

The abdominal area is where all the movement between the chest and the hips happens. It's like a rubber band. You can twist it side to side, bend it back and forth and all around.

The hip/crotch area is the place where we hold all of our weight until it splits down to our legs and feet.

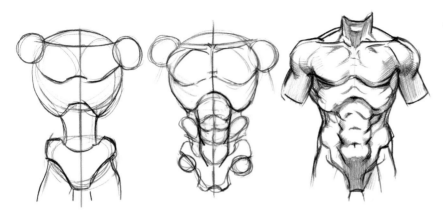

PRACTICE DRAWING THE TORSO (FRONT)

Start with a vertical line. Place a large circle for the rib cage area and a triangle for the crotch area. Connect these with a band for the abdomen. Draw circles for the shoulders and connect these with an arcing horizontal line, which forms the basis for the clavicle. The masses of the chest muscles sit on top of the rib cage, connecting the center of the chest to the shoulders.

Build the abdominal muscles. Define the pectoral, chest and shoulders. Add the lateral obliques, which allow twisting from side to side. The top of the rib cage circle becomes the muscles of the shoulders.

Erase the extra lines and refine the drawing with shadows.

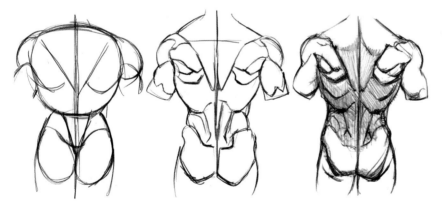

PRACTICE DRAWING THE TORSO (BACK)

Start with a line down the center. Draw the mass for the rib cage and two circles for the rear end. Note that while the abdomen in the front is up into the rib cage, the area below the rib cage tilts under and inward on the back. The rear-end area of the body then tilts back out. Treat this area like a small triangle.

Draw an upside-down triangle for the large mass of muscles from the shoulders to the middle of the back. On each side there is a shoulder blade that connects to the top of the arm.

Once you have the basic shapes in place, add shadows and refine the drawing.

Cool Tip

In all the cool drawings, artists use a trick called *contrapposto* by the more artsy mad scientists. This means that the hips and the chest area are never parallel with each other. If one hip is up, the shoulder on that same side is down; if the shoulder is up, the hip on that side is down. Think of how a figure would naturally look if most of the weight was on one leg. This creates tension and makes your drawing more interesting and fun!

Parts is Parts! (Facial Features)

The eyes, ears, nose and mouth are the fun parts of the face. Draw them incorrectly and the face falls apart, and boy does that hurt! Here are some tips for creating parts to put together.

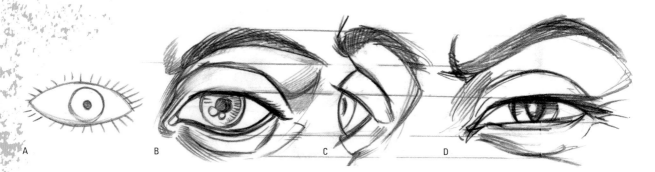

EYES

A. Don't ever draw an eye as a sideways pointy oval with little pokey eyelashes sticking out in each direction (this is good for baby dolls, but not for monsters!). Also, the eye is not symmetrical.

B. Instead, think of the eye as a ball in a hole (socket) with flaps of skin laying over it. The eyebrow sits on the bony ridge on the top of the eye socket. The top of the iris (the colored part of the eye) is usually covered by the upper eyelid. The white of the eye (which is really more blue-gray) surrounds the iris. The pupil is the black hole in the center of the iris that lets in the light. It gets bigger to let in more light (when you are in a dark room or if your victim is scared) and smaller to protect the inner eye from too much light. The tear duct is on the inner side of the eye, and the overlap of the upper lid over the lower lid is on the opposite side.

C. From the side, the eye still looks like a ball in a socket. Draw the lids wrapping over the eyeball.

D. Now try to give the eye some emotion. By squeezing the lower and upper lids together you get the effect of a very mean squint. Grrr...

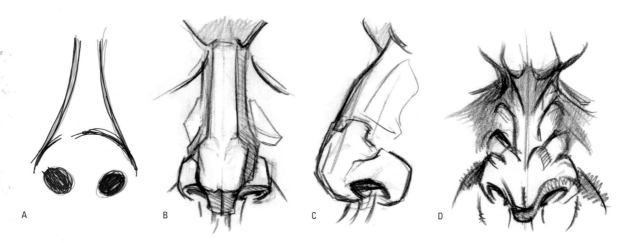

NOSE

A. The most common mistake when drawing noses is making perfect circles for nostrils. People aren't pigs.

B. Look at your nose in the mirror. It's not simply a right angle. There is a structure underneath. The bulb of the nose (the tip) separates into two chunks with nostrils on either side. Above that is the shaft of the nose. Treat this like a solid, boxy structure with edges.

C. Notice that the shaft angles back from the tip until it meets the brow. The brow defines the ridges of your eye sockets. The nostrils are built on the sides of the central shaft of the nose.

D. If you know all these parts of the nose, you can make a cool monster nose. Note all the growly lines.

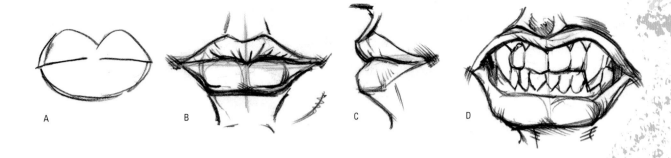

LIPS

A. Don't draw lips like this … ever!

B. Notice the lips split down the center. The top lip goes up from the center and peaks at the edge of the philtrum (that divot underneath your nose), then tapers gently down to the edge of your mouth. The lower lip also splits. The two round parts on either side of the split taper off to meet up with the upper lip.

C. From the side you can see that the lips protrude from the face. The lips rest on a muscular muzzle. The lower lip hangs out over the chin where the muscles tip in to meet with the bone of the chin.

D. Open and spread the lips to bare the teeth. Draw teeth and fangs for the fun of it. Don't forget to look at your face for clues on how to draw these features.

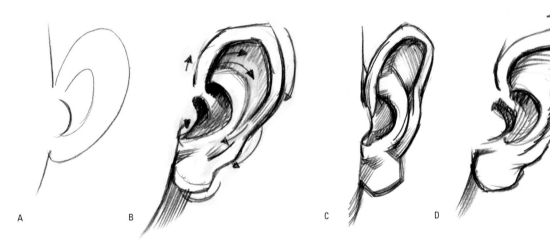

EARS

A. Ack! If you draw an ear like this you will be taken out and … well, just don't do it.

B. The ear's structure resembles a nautilus shell. It starts with a small, semicirclular curve, then a larger semicircle curves outside that. Outside that there is the large shell-like curve, which wraps around the entire ear and tucks into the lobe at the bottom. The lobe is an extra flap of skin that hangs from the body of the ear. The skin at the top of the ear wraps over itself, creating an area that directs sounds into the ear.

C. The same shell structure appears here from the side, curving around and in on itself.

D. Drag the top of the ear up into a point for a wolfy look. Add some tufts of hair, too.

Monster Facial Features

After you've gotten the hang of drawing human features, have fun playing around with different types of monster features. Here are some examples:

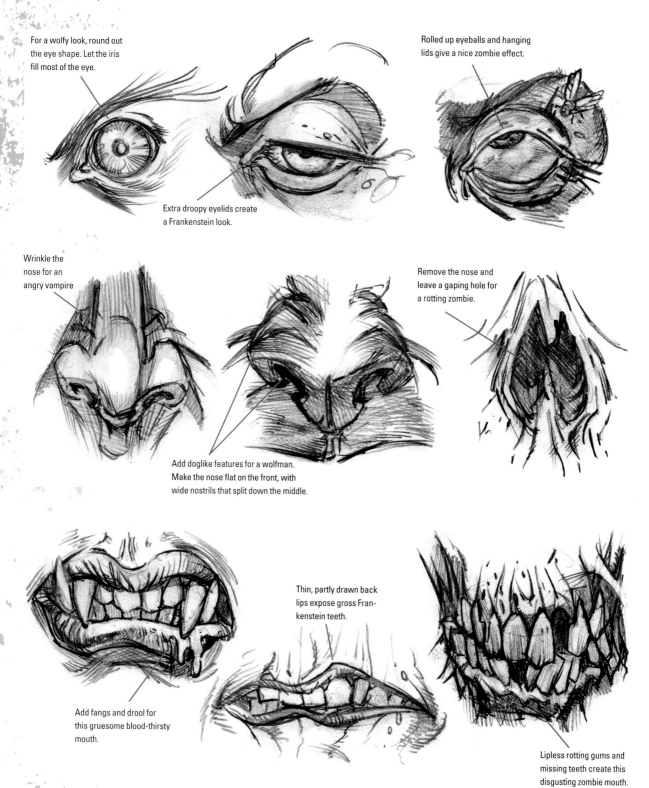

For a wolfy look, round out the eye shape. Let the iris fill most of the eye.

Extra droopy eyelids create a Frankenstein look.

Rolled up eyeballs and hanging lids give a nice zombie effect.

Wrinkle the nose for an angry vampire

Add doglike features for a wolfman. Make the nose flat on the front, with wide nostrils that split down the middle.

Remove the nose and leave a gaping hole for a rotting zombie.

Add fangs and drool for this gruesome blood-thirsty mouth.

Thin, partly drawn back lips expose gross Frankenstein teeth.

Lipless rotting gums and missing teeth create this disgusting zombie mouth.

Hands

You must study the hand to really understand how it works and how to draw it. Here are some examples to help you work on the pieces in this book and beyond.

The Open Hand

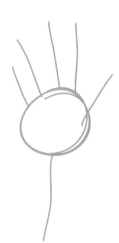

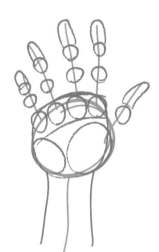

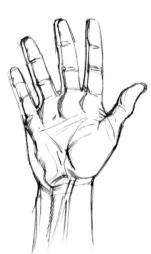

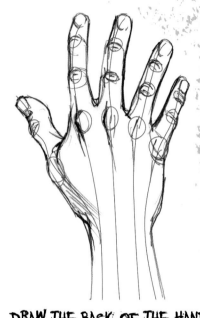

1 Draw Simple Lines
Start with a simple circle. Add five lines to represent the fingers.

2 Add Joint Circles
Draw four small circles where the fingers connect to the palm and a larger circle where the thumb leaves the palm. Also draw circles for the joints and fingertips.

3 Flesh It Out
Flesh out the hand, erasing the extraneous structure lines and connecting the knuckles with the meat of the hand.

DRAW THE BACK OF THE HAND
For the back of the hand, treat the circles as placement for the knuckles and add fingernails. The back of the hand flows out of the forearm, so don't draw a separation between them. The tendons that allow the fingers to move run down the back of the hand, over the knuckles and into each finger. Pay attention to them when you are drawing.

The Fist

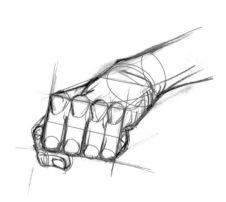

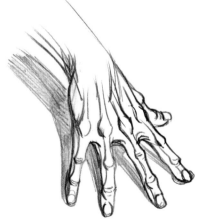

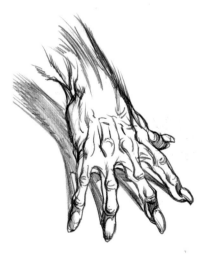

FIST STRUCTURE
Base the fist on a box, then add the fingers as lines across the box. The hardest part is the thumb. Remember to place the knuckles and joints and fill out. Again, use your own hand for reference.

SPREAD HAND
When the hand is spread, use the knuckles as the basis for the finger structure. Note that the back of the hand flows naturally out of the arm.

MONSTER HAND
Add hair and long claws and emphasize the bones and tendons to make a monster hand.

Arms

Study some real arms to really get the hang of drawing them. In the meantime, here are some tips and exercises to try.

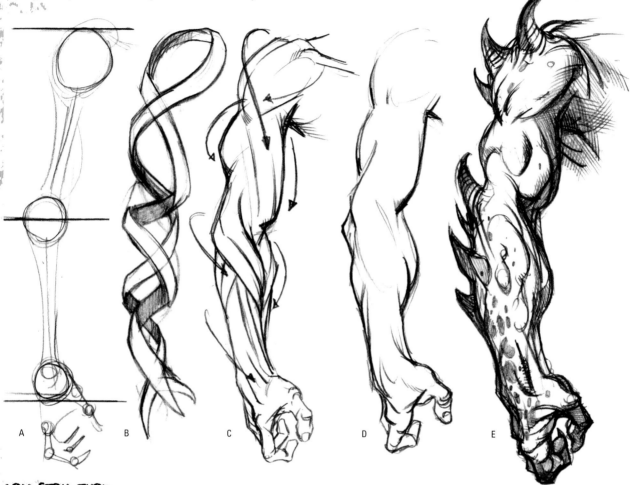

A B C D E

ARM STRUCTURE

A. Draw a through line for the arm, then add circles for the joints of the shoulder, elbow and wrist. Draw lines to connect the joints, thinking about the structure of a skeleton. Draw circles for the knuckles.

B. Think of the arm muscles as ribbons wrapping around the arm, over and under each other, each adding support for the other.

C. Flesh out the muscles, following the flow of the ribbons.

D. Remove extra structural lines and add shadows to the remaining lines in the dark areas.

E. Monster it out with crazy details. Add spikes and scales, and exaggerate the muscles. Don't let the mutations overwhelm the basic arm structure. Keep the lines forming the structural parts more prominent.

BENT ARM

Use the same structural principles for a bent arm. Notice how the muscles wrap around to create the movement and maintain the structure.

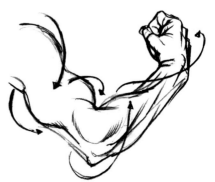

Legs

Use this exercise as a reference when completing the images later in the book. Without this part of the body, your monster won't have a leg to stand on!

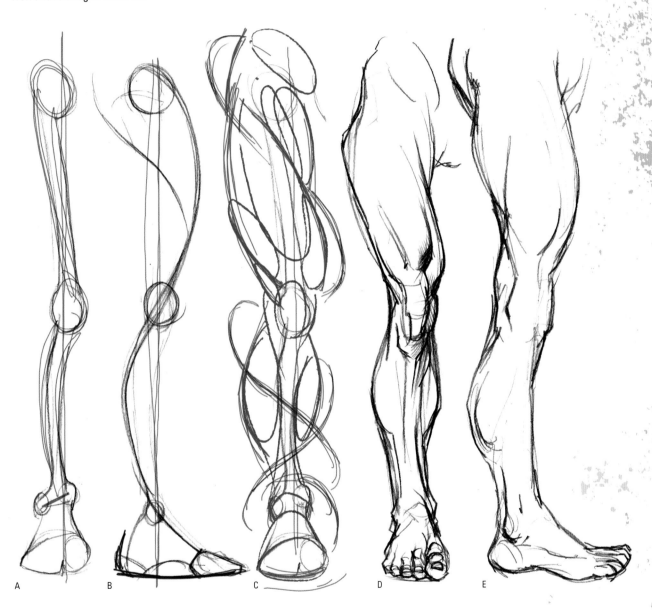

A B C D E

LEG STRUCTURE

A. Start with a main through line, adding balls for the hip and knee. Draw a circle for the ankle and build a shoe shape for the foot. When standing straight, the hip and knee joints are directly over the middle of the ankle joint.

B. To draw a side view of the leg, start the same way. Remember that the hip and knee are right over the ankle. This keeps the body in balance.

C. Create bubbles to place the leg muscles. Be mindful of the flow over and around the knee, behind the calf and over the front to the ankle. Treat the foot like a shoe.

D. Flesh out the leg and erase extra lines and circles. Keep track of the lighting so you know where to shade the lines to create volume. Use deliberate refined lines to draw and shade.

E. Follow the same steps as you did for the front view. Create bubbles for the muscles, connect with flesh and shade.

Putting Down the Paint—My Process

Here is a step-by-step description of how I put down paint on paper. These basic steps apply to all of the demonstrations later in the book.

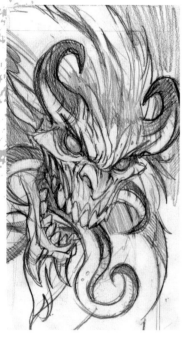

1 Start With a Graphite Drawing

Start with a fairly detailed pencil drawing. Avoid putting in too many pencil tones so you won't have a lot of graphite mixing with the paint.

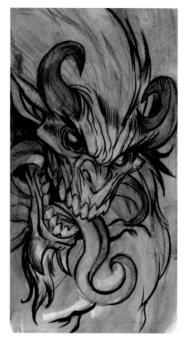

2 Ink the Dark Areas and Details

Ink the darkest areas. You might paint over these later, but the ink will help you maintain the shadow shapes. Ink in the detail areas as well. (Sometimes when you put paint down, the detailed pencil marks wash way.)

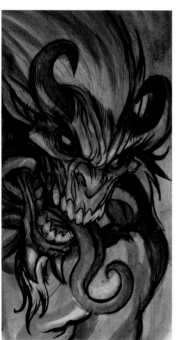

3 Tone the Entire Painting

Tone the entire piece. If it's a night piece, tone it with a Payne's Gray wash. If it's a daytime piece, use a sepia tone. Pay attention to make the darker areas dark and keep the washes very thin where you want to put lighter colors.

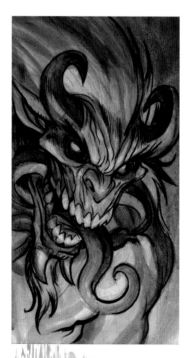

4 Wash in Color

Start washing in the colors. Loosely add color over the earlier washes.

Paint vs. Digital Color

On pages 30–31, I describe my digital coloring process. It doesn't matter which way you choose to work; the idea is to get the same or similar results.

5 Add the Reflected Lights

Decide where the reflected lights are, adding color into the darkest areas of the picture. Try making them all the same color. This indicates that the secondary light source or reflected light has a hue. If the primary light source is a warm yellow, try using a cool blue in the reflected lights. Using complementary colors can create some nice color tension.

6 Add the Details

Paint the details, applying opaque paints over the washes. Keep most of the details in the areas hit by the primary light source. Just like in real life, you need light to see the details.

7 Add Highlights

Tint Titanium White with a little color and dab tiny points of highlight. Be very sparing with the highlights. If you overdo it, they lose their effect and blend into the regular light areas.

8 Add a Second Highlight Layer

Give everything one last thin wash of Payne's Gray, then go into the highlights. Using a no. 0 round, add Titanium White highlights to the horns, teeth, eyes and tongue, then lightly paint in lighter areas on the skin. Place highlights on the more prominent, higher areas. On a fairly smooth surface with a few bumps, the bumps get the highlights. Add highlights to the wrinkles and other lines on the face.

Digital Coloring Process

Sometimes instead of using paints and brushes, I scan my drawing and add the color on my computer. The basic process is similar to when I paint traditionally, so everything I said on the previous two pages about color choices and placement applies here, too.

1 Scan the Drawing

Scan your inked drawing. When working digitally, I sometimes skip the inking stage altogether because I can darken lines and drop in large areas of black once it's scanned.

2 Tone and Create Layers

Tone the lines with the color adjustment tool Photo Filter (Image menu : Adjustments : Photo Filter). Select Cooling Filter to give the drawing a blue tone. Set the Density to 65, and leave Preserve Luminosity checked.

Create layers for inks and undertones. Open the Layers window (Window menu : Layers). Duplicate the Background layer and rename the new layer "Ink." Create a new empty layer and name it "Undertones." In the Layers menu, drag the Ink layer above the Undertones layer. Change the Ink layer's mode to Multiply. This will make the white space invisible, allowing the lower layer to show through.

Add the undertone. Use the Color Picker to choose a color. In the Layers window, click Undertones to make it the active layer, then click the Paint Bucket tool anywhere on the image to fill the layer with the chosen color.

3 Establish Base Color Areas and Add Shadows and Darks

Next, on the Undertones layer, use the Brush tool (using a solid 100-percent opacity brush for complete coverage or a textured brush like the Chalk Brush with a lower opacity for less coverage) to start adding colors. If you lower the opacity on your brush, the color from the last step will come through this color. You can also use the selection tool (Lasso) and the Paint Bucket to fill in larger areas of color. This will establish the basic color areas.

Using the Airbrush set to medium opacity, paint in the darker areas of the painting in the Undertones layer. Start adding the shadows and the darkest color areas.

4 Add a Texture Layer

Create a new layer and paste in a watercolor texture (see "Build a Digital Texture Library" on page 42). Change the mode of this layer to Multiply and rename the layer "Texture." At this point all you will see is the texture.

Lower the opacity of the Texture layer to 45%. Now you can see the image through the texture. The colors of the texture combine with and darken the colors of the lower layers.

5 Pull Out the Lights

Using the Eraser set at a low opacity (somewhere between 20% and 45%), begin to erase the Texture layer in small areas. This will reveal the layers below. This "subtraction" technique will create a modeled effect.

6 Render the Image

Create another layer and name it "Color." Use the Brush and enable either the Airbrush or Chalk option. Set to medium opacity (45% to 75%) and paint all of the primary light areas. Build up the opaque colors, layer by layer. You can "mix" colors by laying low-opacity colors over each other.

7 Add Final Colors and Highlights.

Create a new layer and name it "Highlights." Choosing a small brush size, enable the Airbrush option and set at a high opacity. Place warmer colors in the direct light and cooler colors in the shadows.

Add highlights using colors that are nearly white with just a hint of color (almost 100% opacity). Print it out and scare your mom!

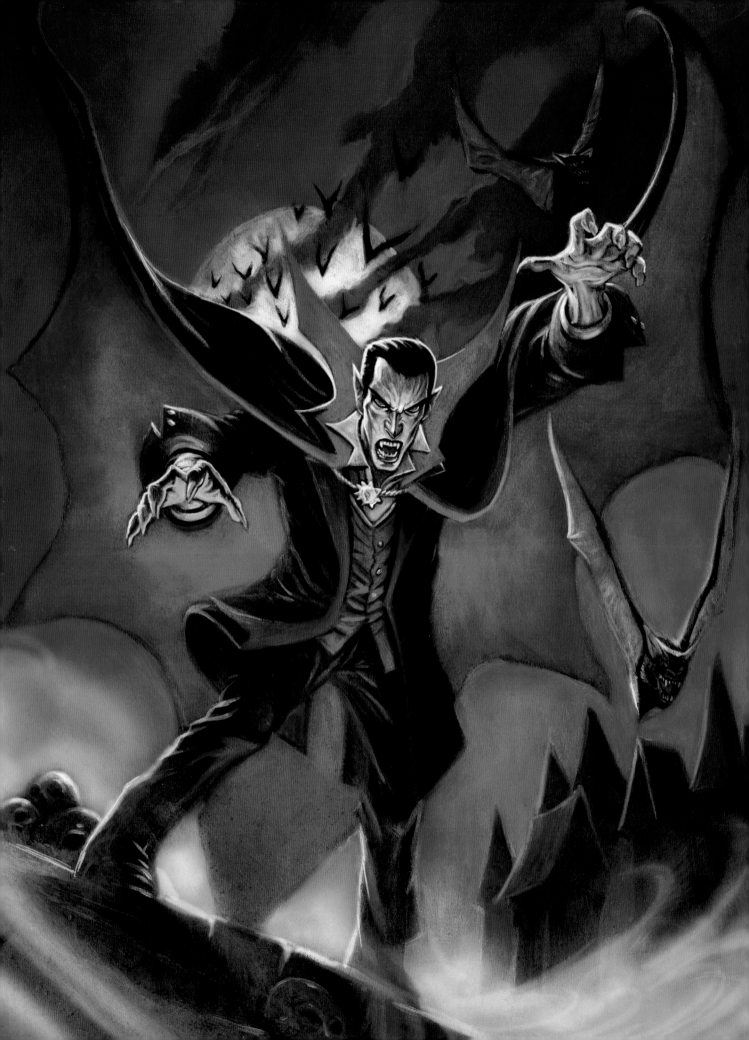

VAMPIRES

VAMPIRES, THEY'RE CREATURES OF THE NIGHT, THE LIVING DEAD. THEY HAVE EXISTED ON THE EDGES of our daylit world silently watching, waiting for the sun to go down when they are free to hunt once again.

Dracula, Nosferatu and a host of other evil blood-sucking creeps lurk in the corners of our imagination. Some are immortal dark princes, able to enter locked rooms in the form of fog, seducing their unsuspecting victims and draining their blood. Others are withered, creepy creatures, who haunt ancient castles, planning elaborate ways of luring victims into their lairs. Still others are beautiful, tragic, seemingly perfect specimens of humanity, who live among us at night, following the late-night crowds, waiting to find an unsuspecting victim alone.

Whichever you want to draw, it will require the dark secrets contained within this chapter. So, dear reader, open these pages if you dare. Unleash your creativity as you unleash your nightmares!

DRACULA

DRACULA: THE PRINCE OF DARKNESS, THE KING OF VAMPIRES, the big mac daddy of death. In Bram Stoker's novel, Dracula had been holed up in his castle in Wallachia (part of Transylvania) for hundreds of years. He was once a prince, but the years had stolen his humanity. Stoker's Dracula was too monstrous for movie audiences, so he got a makeover with a tuxedo, satin cape and slicked-back hair. He's smooth enough to lure in victims, before turning on them.

 I wanted to depict Dracula as you might see him in the foggy night, just after he drops his suave mask, lunging out of the darkness to strike at your throat.

STUFF YOU NEED

ACRYLIC PIGMENTS
Cadmium Red Light, Cadmium Red Medium, Dioxazine Purple, Payne's Gray, Phthalo Blue (Green Shade), Primary Cyan, Titanium Buff, Titanium White, Ultramarine Blue

DRAWING SUPPLIES
drawing paper, drawing pencils, eraser, black drawing ink, sepia ink or umber paint

OTHER SUPPLIES
spray sealant, jars for mixing

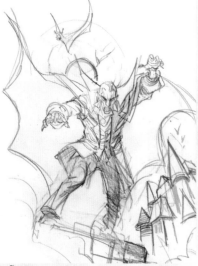

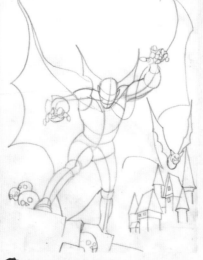

1 Capture the Personality Through Movements

You want to capture the feeling of movement in the attack, but the count should always look as though he's in control. He's not a beast; he is the prince of darkness. He's moving forward towards the viewer. His movement should be aggressive but fluid, not raging out of control. The backbone line should follow gracefully from the top of his head to his back leg. Draw arcing lines for his cape, contraposing his body.

2 Construct the Figure

Draw the large body shapes, starting with the torso and hip area, then the head. Following your gesture, mark points for his hands and feet. This might be harder than it sounds, since it can be difficult to make the arms and legs the right length. Keep trying until you feel like you've got the right spot, then connect your dots to the torso using circles for joints and tubes for limbs (see pages 14–15). These are meant to be loose scribbles. Draw quick, light lines and shapes over and over each other until they seem right.

Composition

The large black form is centered but angled to create tension. The red cape surrounding his neck, the direction of the clouds, the points of the roof lines and the white of Dracula's cheek draw the viewer's eye to the face, which is the most important element of the painting.

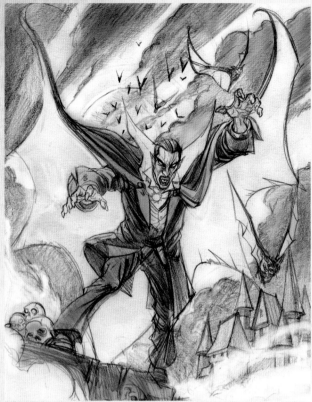

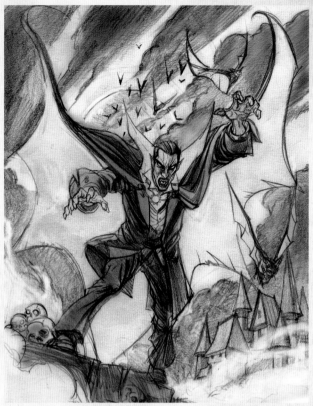

3 Refine the Pencil Drawing

Erase the looser pencil lines, refining them down to a few more accurate lines. Darken, sharpen and complete the lines you want to keep. We're adding ink soon, which will cover the pencil lines, so I worked loosely and didn't worry about erasing every little thing.

4 Finish the Pencil Drawing

Solidify the dark areas. Reserve and limit darkest darks as you would highlights. Add shading appropriate to your light sources. The main light is from the upper left corner. A secondary, dimmer source comes from below as if the moon were reflecting off the damp stone. This means Dracula's right side will be darker than the left.

Now add highlights. Use your eraser as a drawing tool. Pull highlights and lessen shadow intensity. Your lightest lights should be next to your darkest darks. A highlight on the fold of cloth near Drac's right knee will look even brighter if you darken the area directly below it.

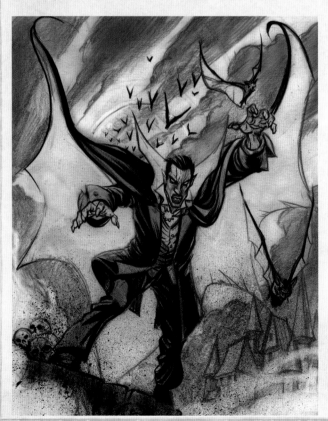

5 Ink the Drawing

I almost always ink my drawings before painting to keep the lines sharp. Without ink, the pencil lines would be obscured by the more opaque paint.

Use ink to establish the darkest parts of the image and reinforce lines to create a sense of dark moodiness and establish sharper contrast. Keep the edges crisp and clean. Check out the Jekyll and Hyde demonstration (pages 68–71) for more tips on inking.

After inking and before painting, seal your drawing with a spray sealant such as Workable Fixative or, my favorite, Krylon Crystal Clear. This is very important because it seals the drawing and prevents any wet medium from smudging or dissolving pencil marks or smearing the ink.

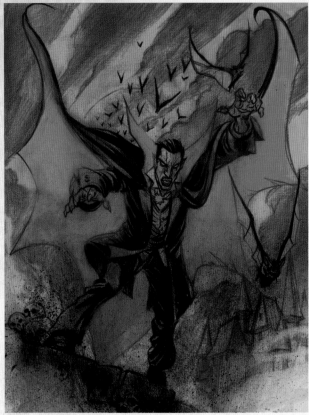

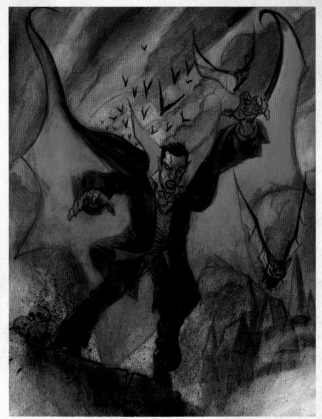

6 Apply a Tonal Wash

Mix lots of water with either a sepia ink or umber paint and lightly cover the entire painting. This establishes a midtone for the entire painting, reducing contrast so that you can add highlights exactly and only where you want them.

7 Apply a Second Wash

Pick a single color that sets the mood and pervades the entire piece. I chose Cadmium Red Medium because it gives the piece a pervasive intensity. Dilute the paint with a lot of water and apply the wash, creating a transparent tone of red over the entire piece. This will keep color harmonies in the same family. Even if you paint a blue over this, you will find red in the entire piece.

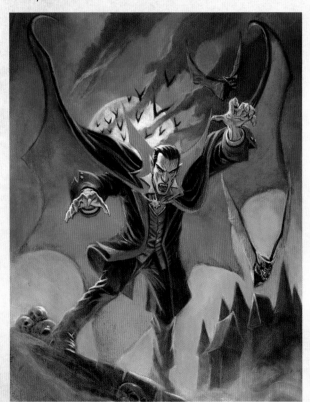

8 Establish Midtones and Lighter areas

Add colors over the red. Keep the paint transparent by thinning it with water (though not as much as in your first color wash). It's best to apply multiple layers, getting darker each time.

Add the more opaque lighter colors, such as the lighter blue-greens of the sky and the pale tones of the flesh. You are creating the final look of the piece, cutting the light areas from the dark, creating a strong sense of contrast and value. Using thicker paint, start painting over ink lines where they seem inappropriate.

Cutting into the edge of the figure with the sky color or background color creates a sharp contrast that brings the figure forward and pushes the background back.

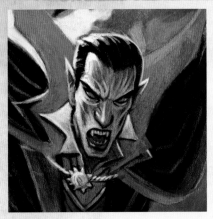

CLOSEUP

To achieve color harmony, tint the entire piece with a thin (diluted) Ultramarine Blue wash. Lay this on with a soft brush to avoid making streaks. This will unify and cool the color theme.

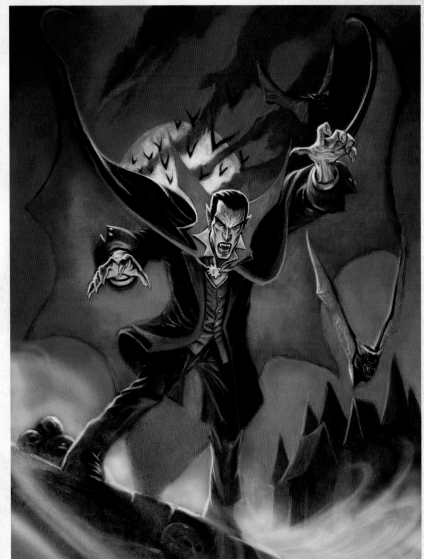

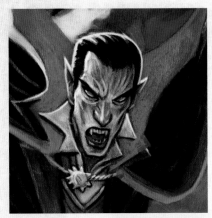

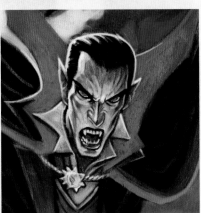

9 Add Highlights and Final Details and Evaluate the Final Piece

The cool whites on the edges of Dracula's head and cape are fairly strong and bright. Reinforce these with Titanium White mixed with a bit of Ultramarine Blue and Payne's Gray. Try to make this edge very crisp.

Use a small brush to paint warmer colors back into the shadowed areas. Bring some warm, pale yellows back into the skin. (Don't add too much yellow or red, or he'll start looking less undead.) Go fairly light with the skin tones, but make sure the moon light source is still lightest. Reinforce the nose structure by darkening the line between the pale blue side of the nose and the dark area on the other side. Do the same to the left side of the face, darkening the line between the cools and the warms.

Add a warm highlight to the bottom and right side of the eyes. This implies a warm light source from the lower right. It also makes his eyes look shiny, red and wet. Add highlights to the teeth and the hands. Add warm underlights to the entire figure. Add the whitest whites to the highlights. Look for details that were obscured by paint and replace them. Sharpen the hard edges and soften the edges that you want blended. Add shiny highlights to the fangs, eyes and face. Details and highlights draw the viewer's eyes to the important parts of the image.

VLAD THE IMPALER

IN *DRACULA* BY BRAM STOKER, THE VAMPIRE TELLS JONATHAN

Harker of his ancestor Vlad the Impaler. The historic Vlad the

Impaler was a great warrior, but an evil one. His surname Dracula comes

from the order of knights he belonged to: the Order of the Dragon, or Dracul. Rumor has it he

ordered his men to impale 100,000 enemy troops on pikes and leave them on the side of the

road to frighten the troops entering Transylvania. Blood stained the countryside. Did he

bathe in the blood of his enemies for immortality?

Vlad would have carried a bloodstained sword, worn beautiful armor and had the

visage of a monster to scare away the much more powerful Turkish Army. He would

have looked like a demon on earth.

STUFF YOU NEED

ACRYLIC PIGMENTS
Cadmium Orange, Cadmium Red Light, Cadmium Red Medium, Cadmium Red Deep, Cadmium Yellow Medium, Cadmium Yellow Deep, Cobalt Turquois, Payne's Gray

DRAWING SUPPLIES
drawing pencils, eraser, black drawing ink, sepia ink, drawing paper, photocopy paper for sketches

OTHER SUPPLIES
spray sealant, jars for mixing

Composition

This composition is a classic triangle. The head of the figure, our point of interest, is at the top of the triangle. The legs and the angle of the sword create the wide base. The triangle is a strong simple shape, giving the impression of power.

Think about where the image leads your eye. Where do the shapes in the piece compel you to look next?

1 Capture the Personality Through Movements in a Gesture Sketch
Capture Vlad's personality through movements. He should convey power and danger. Spread his legs—this gesture denotes stability and strength. Thrust his hips forward and his shoulders back. His right hand is down, holding his sword at the ready; his left hand grasps a bloody head.

2 Construct the Figure

The figure in this piece is mostly obscured by armor, but you still need the basic structure. Draw the body without the armor first. Pay close attention to the proportions of the body; they don't change just because the armor is in the way.

Add the large shapes for the armor. Notice the basic shapes again: the top of the sword is a triangle, and the shield is a circle. The helmet and the wings are also simple shapes.

3 Refine the Pencil Drawing

Armor is made to work with the body. It bends where the body bends and follows the same movements. Place the armor and clothes lightly at first, allowing the cloth to wrap around the figure and the armor to wrap around the arms, legs and torso. Erase the body lines before you complete the drawing.

4 Finish the Pencil Drawing

Create textures and put the black shapes in place. The light is coming from underneath Vlad on both sides, so the major shadows will be in the middle of the figure.

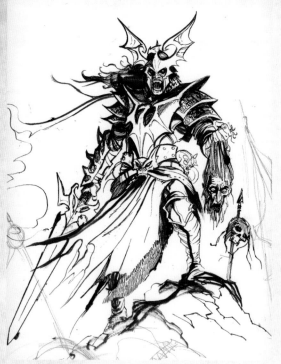

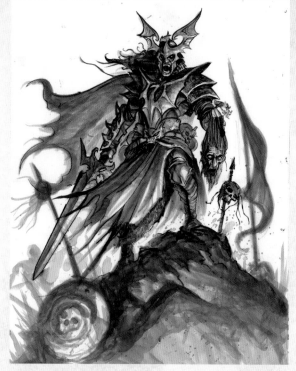

5 Ink the Drawing

Inking creates a nice dark base for the final paint. This step forms the shadow structure for the entire painting. Blacken the darkest areas of the pencil drawing, then add lines to support the black shadows. Don't worry about having a few mess-ups and splatters.

6 Apply a Tonal Wash

Put some sepia ink in a jar and begin adding water. Test the mix on a separate piece of paper. Experiment until you find a medium tone of ink. Cover the figure and the ground with a light ink wash. Start light, building the color darker and darker.

Treat this as a tonal structure, letting the darker tones define the lighter areas. Lower-contrast areas tend to recede from areas with higher contrast. So keep the darkest ink areas for the figure and lower the contrast in the distance. This is called atmospheric perspective.

Spend time in this stage establishing midtones, textures and shadows, leaving whites for the light areas of the painting. After you've gotten the tones where you like them, spray the painting with one of the fixatives mentioned in the tools section (page 8).

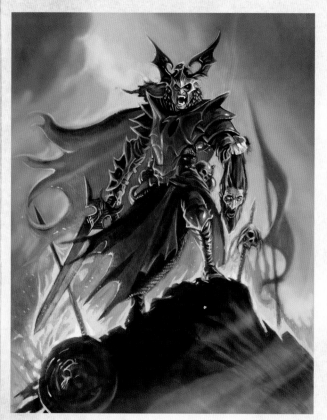

7 Apply Color Washes

Keeping your paint loose and wet, paint in a color area in the background first. Wash Payne's Gray mixed with a touch of Cobalt Turquois into the background/sky, laying it over the flag and making clouds by darkening some areas. Remember that the light should be falling around Vlad to reinforce the composition. For the fire in the midground, use Cadmium Yellow Medium and Deep and Cadmium Orange. On Vlad, wash in Cadmium Red Deep and Medium to form the armor and trim. On the cape, mix Cadmium Orange and Cadmium Red Light.

8 Add Opaque Colors and Evaluate the Final Piece

Always work from thin to thick: Use thin washes to establish larger areas of color, then apply thicker opaque paint to solidify areas of the painting. Eventually many of the washes will be covered with thicker paint. This doesn't mean the washes are unimportant. The many layers of paint create depth and unity. If you skip right to thick paint, your painting will never look quite right.

By putting the fire in the midground, we've broken some of the rules on this piece. The fire acts as a light-value area to contrast with the legs and body of the figure. It creates a nice silhouette for him. It also helps strengthen the triangular composition of this piece.

Keep the warm reds up near Vlad's head. Allow the figure to get darker and less colorful with lower contrasts as you move away from his head.

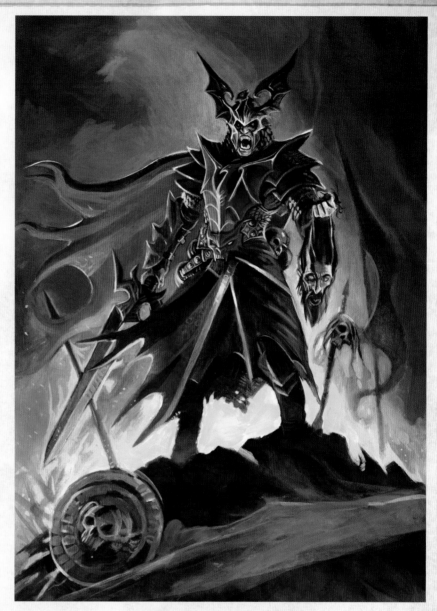

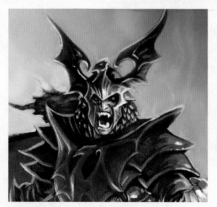

ADDING HIGHLIGHTS

When you add highlights and reflections to Vlad's armor and skin, remember that the cool colors will be reflecting from the right and the warm colors from the left. Keep your paint colors separate: cools on one side, warms on the other.

DRACULA'S KISS

HE COMES AS A MIST; NO DOORS CAN STOP HIM. AFTER HIS first bite, Dracula's power over his victims is complete. He calls them from a distance, and they come to him in a trance, willingly giving themselves up to his embrace. They love their master and will give their lives to serve him.

STUFF YOU NEED

PIGMENTS
watercolors or acrylics (optional for creating digital texture library)

DRAWING SUPPLIES
pencil, tonal pencil, eraser, photocopy paper for sketches

OTHER SUPPLIES
scanner, computer, photo-editing software

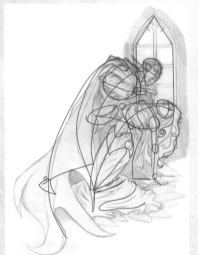

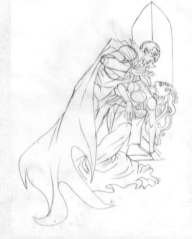

1 Capture the Personality Through Movements in a Gesture Sketch

Think romantic swoop. Dracula is arcing over the prone figure of the girl, his cape flowing from the ground up over his back, drawing you to his face. Her figure is limp and the gesture weak and open. Let the backward curve of her spine flow up to the back of her head. Her hair completes the line running through her body, flowing from her face back to the floor. Dracula's head breaks the natural curve of his body; it's back and ready for a bite.

2 Construct the Figures

You can't see the legs, but they're there. Without drawing them first, you won't know how to handle the clothing, so construct the entire figure. The relationship between the legs, hips and torso creates the backward curve of the girl's body. Swing her hips away from us. Lean her rib cage toward us, exposing her upper chest and neck. The head tilts farther back, pivoting on the ears, giving us a full shot of the underside of her chin. Drac's legs are spread, and the leading leg holds all of the weight of the girl and his forward movement.

Composition

To draw the viewer's eye to the main point of interest (Dracula about to bite the neck), base the composition on a triangle. Everything else in the piece is there to act as a compositional tool to bring the viewer to that place: Dracula's cape flowing up from ground, the girl's body arcing upward, Dracula's arm, even the straight window bar points down to the neck of the girl.

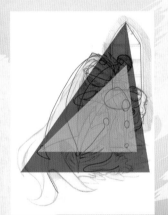

Build a Digital Texture Library

In this demonstration I'll show you how you can scan a traditionally painted wash and use it in a digital painting. Start by covering a sheet of paper with a watercolor or acrylic wash; let the wash dry, then scan it. Keep creating and scanning washes, and soon you'll have your own library of interesting textures that will add depth to your digital paintings.

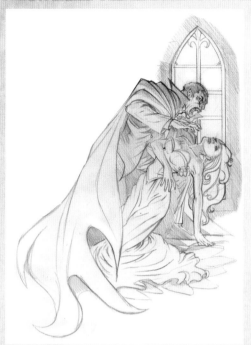

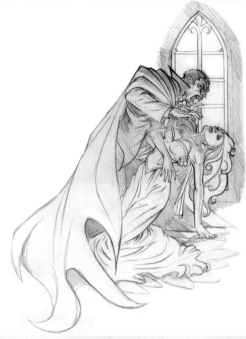

3 Refine the Pencil Drawing

Wrap the clothing around the figures. Study reference photos of cloth, dresses and suits to see how the cloth moves over and around the figure, giving a sense of what's underneath. Notice where the seams are and how they affect the direction of the cloth. The cloth will stretch to reveal the movement of the body. Use different pencil edges to get the textures you need to make the cloth believable.

4 Finish the Pencil Drawing

Erase the loose lines and work over the remaining lines until they're simple and clear. Use tonal pencil to shade in areas. Treat the shadows as shapes so that the image will be clearly broken down into shadow and light. All lines, edges and shapes should be worked out at this point. We're ready to scan.

5 Add Digital "Color Wash," Then Make the Window Glass Blue

Scan your finished pencil drawing. (If you prefer to finish this painting with traditional paint and brush methods, you can.) Duplicate the background layer and rename the new layer "Drawing." Change the Drawing layer's mode to Multiply.

Open a previously scanned wash (see "Build a Digital Texture Library" on page 42). Select the entire canvas, copy the image, then switch to your scanned drawing and paste. In Photoshop, a pasted image automatically goes onto a new layer. Rename the new layer "Wash," then drag the Wash layer beneath the Drawing layer. Note that the pencil lines are still clearly visible.

Next, select the glass window panes using the Lasso. Fine-tune the selection until you've got it how you want it. (Tip: When you're using the Lasso or Magic Wand, holding down the Option key [PC: Alt] subtracts from the current selection, while holding down the Command key [PC: Ctrl] adds to the current selection.) Then, choose the Hue/Saturation tool (Image menu : Adjustments : Hue/Saturation) and use the sliders to alter the color of the window glass to a blue similar to the one I've used here.

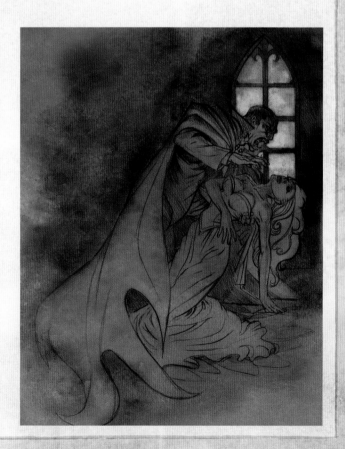

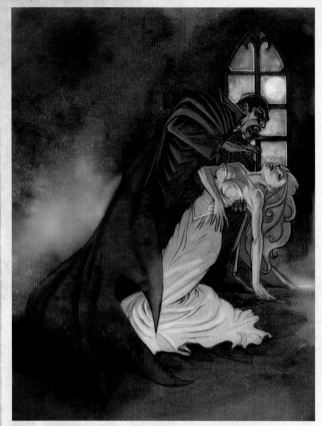

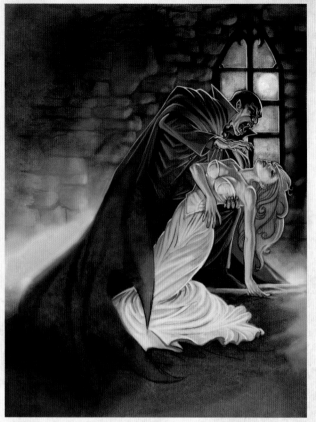

6 Establish Major Color Areas and Opaque Colors

Continue creating the base colors by selecting an area and using the Hue/Saturation adjustments to alter the existing color to whatever it needs to be. (You can also use Image menu : Adjustments : Levels.) For example, alter the girl's skin tone to a pale orange, and change Dracula's suit to a deep blue-purple. Adjust the entire cape with some green and dark blue. Use the Elliptical Marquee tool to select a circle in the window, then adjust its color toward white to create the moon (allow some texture to remain in the moon to create the appearance of craters).

Create a new, empty layer named "Opaques." Leave this layer on top of the others and keep the default layer mode of Normal. Begin to paint opaque colors on this layer, focusing on the areas where the light from the window hits the figures. Using the Brush tool in Airbrush mode or with the Chalk shape and at a low opacity, paint over these areas with lighter or darker colors to further define the image. Add deep blue-gray to the cape, defining its flow. Add white and yellow to the girl's dress with the Airbrush. For the skin, apply a creamy, pale peach color in the light area, and a deeper orange-brown in the darker areas. Add a pale blue fog with a large, low-opacity Airbrush. The contrast brings the figures out of the background.

7 Add Lights, New Background Texture and Highlights

Keep adding color to Dracula and the girl. Keep in mind that the main light is from the foreground, and a pale blue light is coming in through the window. Add some blue highlights to areas such as the girl's far cheek, the edges of her hair, the back of her arm and the back of her dress. This will develop the feeling of volume.

Add a dark stone background texture and name it "Wall Texture." I scanned an old photo of a stone wall I had, then copied and pasted it into the painting. I then moved the Wall Texture layer just above the Wash layer from step 5. Set the Wall Texture layer to Multiply mode so the texture comes through the light areas. Use the Eraser to remove the stone texture from behind the figures and from the window panes.

Continue developing the lighter areas with opaque paint and a low-opacity Airbrush. It's important to build these up gradually until you achieve highlights. This is similar to the painting process of layering opaque paint over washes.

Develop a pale blue rim lighting on the figures. The rim lighting gives the figures a glow and separates them from the background.

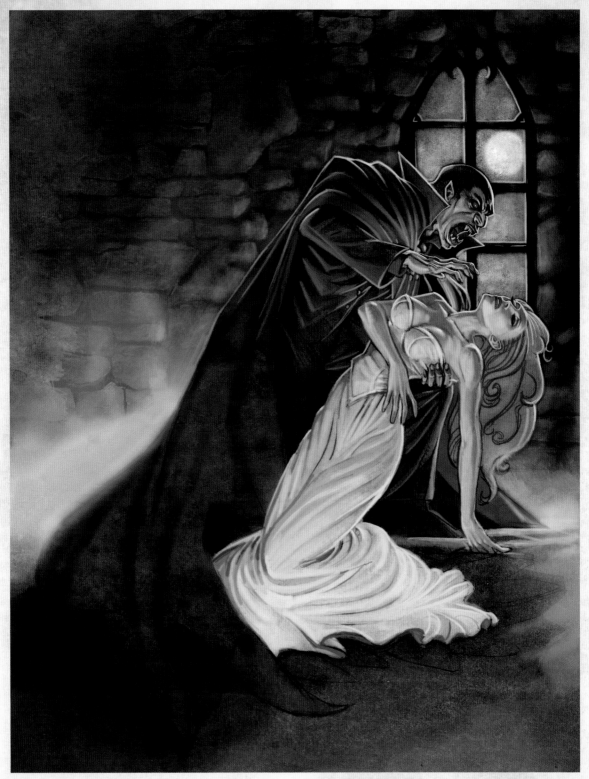

8 Add Highlights and Final Details and Evaluate the Piece

Evaluate your work and make a few final adjustments. I added a color-adjustment layer (Layer menu : New Adjustment Layer : Color Balance) just above the Background layer and used the sliders to make the background a cooler blue. I felt that the reds and purples in the back were causing confusion, and I wanted a unifying color to bring the focus on the figures. Add a few detail highlights (see page 31, step 7) to Dracula's eyes, nose and teeth to make him more exciting. I also decided to redraw the girl's legs so that they're in front of Drac's cape. I felt she looked cut off before. The artist often has to make big, risky changes in the final hours to make the piece better. Art is risk. Don't worry—just create!

DEMONSTRATION
NOSFERATU

IN THE CLASSIC FILM *NOSFERATU: A SYMPHONY OF HORROR*, filmmaker F.W. Murnau had to change the name of the villain from Dracula to Nosferatu because he couldn't get permission to use the names from the novel. Even so, this portrayal of Dracula is more accurate to the novel than the more familiar Bela Lugosi version. Nosferatu is tall, stooped and pale, with large overlapping teeth protruding from his jaw. He has large, bony hands with sharp, long fingernails and red, ratlike eyes. This isn't a debonair count. Nosferatu is a monster.

STUFF YOU NEED
ACRYLIC PIGMENTS
Burnt Umber, Cadmium Red Medium, Payne's Gray, Raw Umber, Titanium Buff, Titanium White, Van Dyke Brown

DRAWING SUPPLIES
pencil, black drawing ink, sepia ink, drawing paper, photocopy paper for sketches

OTHER SUPPLIES
spray sealant, jars for mixing

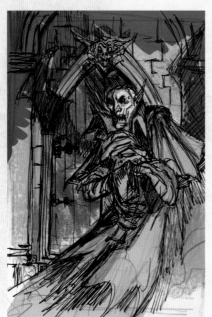

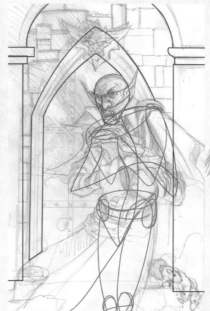

Composition
After working with compositional sketches, I decided to use the door as a holding compositional device. Nosferatu breaks the edges of the doorway that frames him, making for a more interesting composition. The metal strapping on the door acts as a secondary compositional element that brings the eye back to the figure. All of the little lines making up the wall and the door act as a texture that makes Nosferatu come forward.

1 Capture the Personality Through Movements in a Gesture Sketch
Use a ballpoint pen to sketch a quick layout (see Gesture Drawing, page 18). Scribble quickly to create the mood and composition you want.

Nosferatu's stance seems cowering and timid, but beneath that timidity lies danger. Ratlike, he stoops, arms in, eyes peering over lower lids, watching, ready to strike. He's not flamboyant like Dracula; he's quiet and creepy. He hides in his ancient castle and hunts his prey from the darkness. Capture this nature in the gesture sketch: arms lifted and held in tightly, almost hiding his body, head tilted back, looking at his prey.

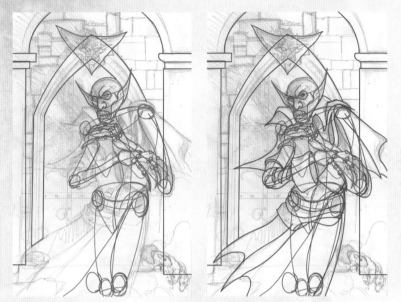

2 Construct the Figure

This figure is all about the head and hands. His arms are unnaturally long, so don't worry about proportions. However, always be consistent when distorting figures. You can make arms really long, but it'll look weird if one arm is longer than the other.

The fingers are really long and ratlike with crazy fingernails that look as though they could spear a fish. His teeth are sharklike, each one a sharp fang capable of ripping out your throat. His ears are long and pointy like a bat's ears, able to hear a hunter approaching from miles away. He wears a long coat, old and ratty. It looks as if he's been wearing it for five hundred years. Imagine he smells of old dirt.

3 Refine the Pencil Drawing

Be sure to consider the light source, which is coming from below and to the right. If you need help figuring out how the light would work, get a flashlight and look into the mirror. Make creepy faces and watch how the light works over your face and hands. Remember to define the shadows as shapes. When light sources are as strong as this, the shadows tend to create a consistent shape that runs across the figure, away from the light source at 90 degrees.

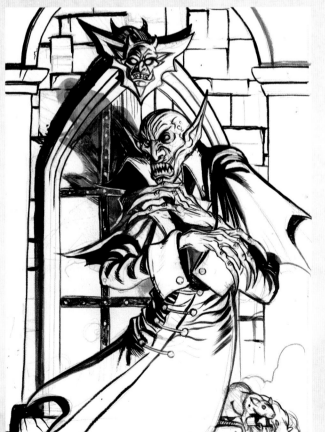

4 Ink the Drawing

Instead of going for a finished pencil look, I decided to ink this one. For this piece, I recommend working with brush and ink. The brush will afford you nice line weight changes from thick to thin. Play around with different line weights. The lines in the background tend to be thinner with less areas of black, while lines in the foreground are thicker and have black shadows.

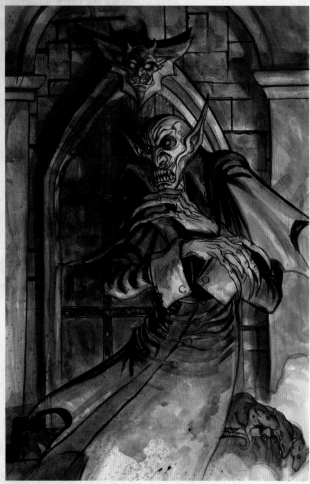

6 Establish Darks and Edges

Really work at getting those dark shadows in the sepia tone. This will help when you are adding the opaque colors on top.

5 Apply a Tonal Wash

Wash over the black ink with sepia ink to start creating tones, keeping in mind the light source at the bottom right. Use the ink to create textures. Later, when you add color washes, these textures will show through. Consider the tonal values. If the light is coming from below, put long shadows on the far side of objects such as the doorway. Nosferatu casts a long shadow upwards on the wall. The stones react to the light individually but also as a group. Treat the lighting of each stone individually, then wash over the area to create an even tone, getting darker as you move away from the light.

7 Establish Opaque Tones

Start putting in the opaque colors. Create textures over the washes and reinforce the darker areas. Reserve the opaque paints for the figure. The lower-contrast background will recede backward. Reserve true white for little highlights. The more you restrict the whites, the more power they have.

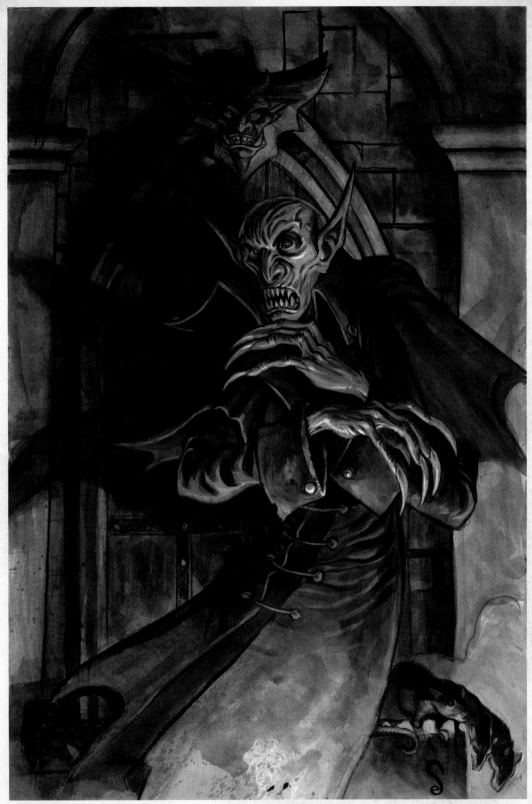

Add Highlights and Final Details and Evaluate the Final Piece

8 Drop in those final highlights for saliva on the fangs and glistening spots in his eyes. Use contrast to your advantage. For every light, there's a dark. Against the lightest light, there is always the darkest area of dark. For example, if there's a bright white glint in his eye, there will be a corresponding dark right next to it. Voilà! You have a creepy, creepy Nosferatu!

VAMPIRE KID

THIS IS A CREEPY IMAGE: A YOUNG KID TURNED INTO A VAMPIRE. Maybe he's more vicious than the older vampires. He's been trapped in a kid's body for five hundred years and hates it. He brutally takes out his anger on his victims. Most people underestimate him until it's too late. The kid drains them of their blood before they know what's happened. We just caught him after feeding. He looks at us threateningly. We're next.

STUFF YOU NEED

DRAWING SUPPLIES
pencil, eraser, kneaded eraser, quill pen or technical pen, dip pens (optional), black drawing ink, sepia ink, drawing paper, photocopy paper for sketches

OTHER SUPPLIES
scanner, computer, photo-editing software, reference photos of Victorian-era clothing

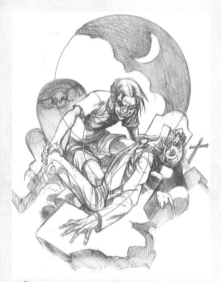

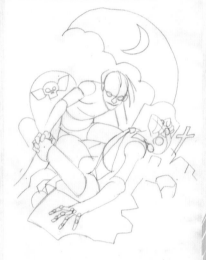

1 Capture the Personality Through Movements in a Gesture Sketch

The gesture captures a crouching monster, hunched over his prey. The curve of his back runs from the back of his neck and around to his pelvis in a C shape. His crouched legs sharply turn under at the knees, so we can't see his feet. One arm extends to the face of his victim, while the other rests on the victim's knee.

The victim is bent backward, limp, his neck pushed back at an awkward angle. The forward hand is still tense, though he's lost the struggle.

2 Construct the Figures

Use the arc of the boy's back to build the figure. Draw lines for the arms and legs off that arc. Place circles for the head, shoulders, rib cage, hips and knees. The shoulders drop and the hips rise on the right, extending the left side of the body and compressing the right. This gives him a hunched, feral look. Pay attention to the balance so that he doesn't look like he's falling over. A stumbling vampire isn't very scary.

Draw crosses to place the facial features, and lines for the finger placement. Use circles to place knuckles and other details such as eye sockets and ears. Treat this step as a road map for the later stages.

Composition

The scene takes place in an old graveyard, where the tombstones are pointing in every direction. This could lead to a very distracted composition with objects pulling away from each other. Use the giant circle of the moon to hold all of the disparate elements together. This is an old trick that was used wonderfully by guys like Norman Rockwell. The circle leads your eye back into the center. Allow the bottom of the piece to freely extend toward the edge of the paper. The circle holds in the top, but the bottom doesn't want to be contained. This grounds the image.

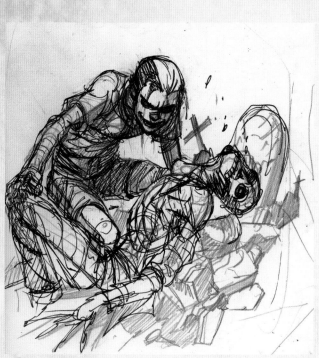

3 Refine the Pencil Drawing

Include only the important lines. Imagine that each line has a story to tell. If it doesn't, eliminate it. This is especially important now that we're working with ink.

Don't overdraw in the pencil stage. Keep it light so that you can erase it after you've gotten the ink down. Also, ink resists if the pencil is too deep into the paper, and you will have trouble finishing your lines.

4 Finish the Pencil Drawing

The light source is coming from behind and to the left. All the shadows should be perpendicular to the light source, so shade at 90 degrees to the light source. Everything that turns away from the light will be in shadow. Since you will be inking this piece, draw lighter with the pencil. In this case, lay in the shadow lightly so the pencil doesn't cause the ink to sit on the surface rather than absorb into the paper.

Add Victorian flair to the clothes to show how old he is. Old jackets were made of heavy material and will hang straight down from the shoulders. Reference Victorian clothing styles on the Web or in books.

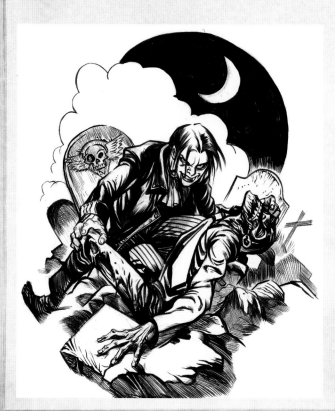

5 Ink the Drawing

Focus on the shadow areas that are most important to your image (look for large areas of dark in the pencil drawing). Use a kneaded eraser to pick up some of the graphite in these areas. Then, using your brush (or marker), recreate these areas in ink. Craft the shadow shapes. Definite edges define the form of your drawing.

After the larger shadow shapes are established, use a fine inking tool (technical pen, quill or thin brush) to recreate the outlines of the drawing. Decide where you need hatch marks and where you might need more shadow or thicker lines. Thicker lines help describe objects in the foreground. Objects defined by thin lines tend to recede into the distance. For organic things like people, animals, cloth and wood, use more varying lines (brushes and dip pens work well for this). For hard, sharp objects made of metal or plastic, use a steady, unvarying line (use technical pens for these lines).

6 Scan, Then Manipulate Layers

Scan the drawing. Duplicate the Background layer and rename the new layer "Inks," then change the new layer's mode to Multiply. Use the Levels adjustment (Image menu : Adjustments : Levels), which controls the tonal range of the image, to get rid of stray pencil marks and clean up the edges of the ink. (Scoot the black slider to the right to darken the drawing, then move the white slider to the left just enough to remove the lightest lines.) Keep adjusting until the lines look clean up close.

Paste in a premade colored texture (see "Build a Digital Texture Library," page 42). Rename this layer "Texture" and change its layer mode to Multiply so you can see the Inks layer through the texture.

Color Breakdown

Start with more intense colors, and then bring them down to earth. The mood of this piece requires subtle colors. At night, most colors become more about tint than hue. (Our eyes have trouble discerning hue due to the low levels of light.) Also limit the range of tones. There aren't many bright areas in this scene. Darker tones create a nighttime feel.

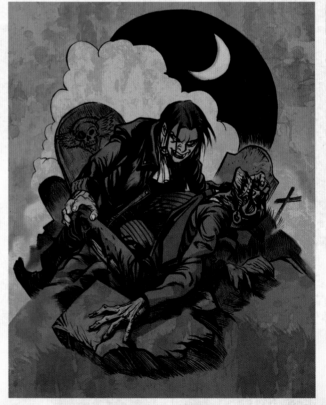

7 Create the Base Color Areas

In the Layers window, click Texture to make it the active layer. Create the base color areas by selecting areas with the Lasso, then using color adjustment tools (try Image menu : Adjustments : Hue/Saturation, Image menu : Adjustments : Color Balance, or others). The Lightness slider (part of the Hue/Saturation tool) is useful for lightening the clouds.

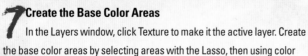

8 Add Final Touches

Create a new, empty layer named "Opaques." Leave this layer on top of the others and keep the default layer mode of Normal. Using the Brush tool set to Airbrush, create subtle highlights in the whites of the eyes. Add shadows from the hair on the forehead. All the details add to the creepiness. Done!

GOTH VAMPIRE

YOU'VE SEEN HER AT NIGHT, DOWNTOWN IN THE NIGHTCLUBS, at the late-night diners hanging out with the humans who seem to worship her, not realizing the threat among them. She dresses in older styles, mixing Victorian costumes with modern or even futuristic accessories. She floats around the room, attracting prey with her allure rather than hunting like a beast. The prey almost beg to be victimized, wanting so much to be loved by the vampire.

STUFF YOU NEED

DRAWING SUPPLIES
pencils, eraser, drawing paper, photocopy paper for sketches

OTHER SUPPLIES
scanner, computer, photo-editing software, reference photos of Victorian-era clothing

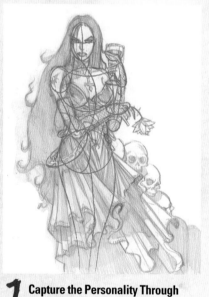 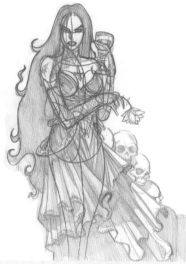 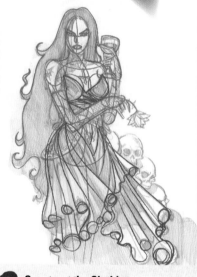

1 Capture the Personality Through Movements in a Gesture Sketch

Start subtly when drawing the goth. Unlike the other vampires, her movement isn't violent. Sketch the initial drawing with smooth shapes and curves.

2 Construct the Figure

Follow from the head down to the chest and continue to the hips. From there, follow the movement down her legs, even though you won't see them when she's wearing her big dress. Always draw the figure without clothing before you draw the clothing over top. This way you will know what the clothing falls over, and the drawing won't look flat.

3 Construct the Clothing

Goth vampires often dress in the Victorian manner. Old dresses (probably dating from when they died), broaches, tattered nylon sleeves and black flowers are appropriate goth garb.

The folds in this goth's dress are called hanging folds. Structurally, it's almost like a bunch of cloth tubes bunched together at the top, draping down to the bottom.

The trick is to treat the folds as solid objects. Draw circles at the bottom of the fold lines you've made, essentially creating a cone or cylinder shape. Now render these the way you would render any cylinder to give it volume.

4 Finish the Pencil Drawing

Connect the dots and fringe the lines together. As you work, erase the underframe of the drawing so you have only the lines you want.

The clothing is key to creating this vampire's personality. Most goth vampires I know like form-fitting tops and big, flowy bottoms. This vampire has a long, luxurious dress. Draw curves coming down from her waist, out and around her body, as if the dress folds down in the front and wraps around from behind. Use big, flowing, curving lines and have fun with the lines and shapes.

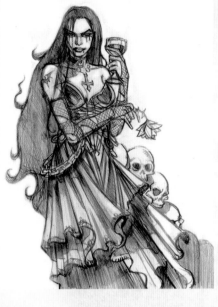

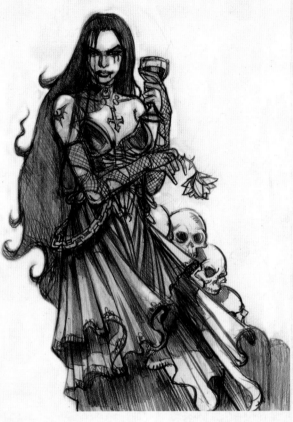

5 Scan and Tone the Drawing; Paste in Texture

Scan the drawing. Duplicate the Background layer and rename the new layer "Drawing," then change the new layer's mode to Multiply.

Infuse the entire drawing with a reddish hue by choosing Image menu : Adjustments : Photo Filter, then selecting Red as the filter color. Experiment with the Density slider until you like the results.

Next, paste in a dark texture you scanned in earlier (see "Build a Digital Texture Library," page 42). Rename this layer "Texture" and position it below the Drawing layer. A deep red or maroon texture makes a nice base for the other colors in this piece.

6 Establish Midtones and Darks

In the Layers window, click Texture to make it the active layer. Select the dress with the Lasso, then use Image menu : Adjustments : Levels or Image menu : Adjustments : Hue/Saturation to darken it and bring out the grays. Use the same method to create middle to dark tones on the figure. Tone the skin areas with a blue-gray, paying attention to the structure of the anatomy.

The darks have been mostly established by the combination of the pencil drawing and the tone from behind. If there are significant gaps, use the Eyedropper tool to sample dark red colors from the Background layer, then use those reds to tone areas on the Texture layer.

7 Establish Lighter, Opaque Tones

Create a new, empty layer named "Opaques." Leave this layer on top of the others and keep the default layer mode of Normal. Using the Brush tool in Airbrush mode, start developing the lighter areas with opaque color. (If you were painting, you'd do the same with opaque paint over the washes.) Pay attention to the relative coolness or warmth of your colors as you apply them. Treat the light coming from the left side of the piece with a cooler tone than the light from the right.

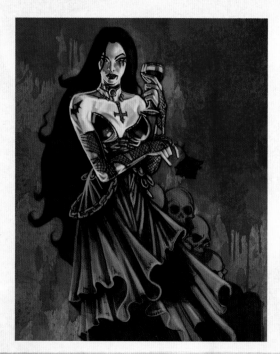

8 Create a Major Color Shift

I decided to change the color direction dramatically. Using the Lasso tool, select the background on the Texture layer and adjust the color to a deep, rich, bright red using Image menu : Adjustments : Hue/Saturation. This adds a lot of life to a previously dark piece. To finish, I toned the deep reds with some brighter reds to add sharp color contrast to the edges of the figure, allowing the figure to stand out more from the background.

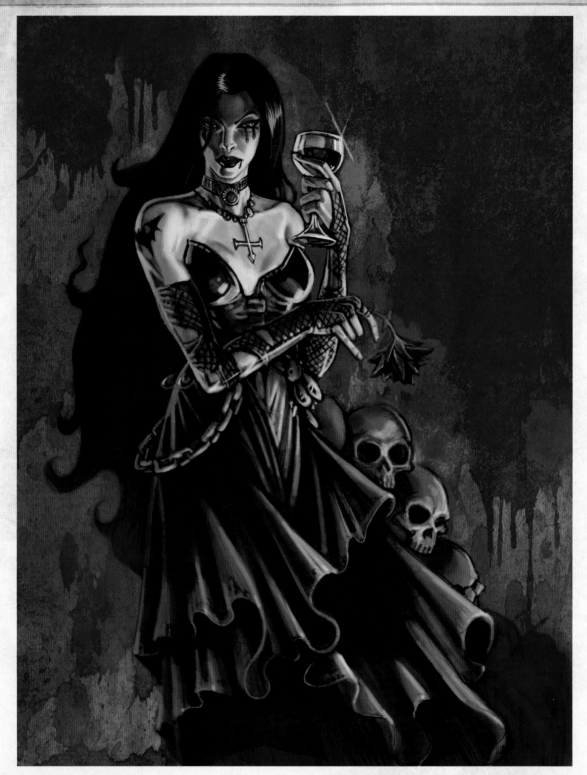

9 Add Details and Highlights

Create a new layer above the pencil layer for highlights and another layer below the pencil layer for darker colors. On the lower layer, add the detail colors: greens for the rose stem, reddish gray for the chains, and touches of red in the glass of wine.

Select and darken the shadow areas of the figure by adjusting the saturation up and the lightness down (Image menu : Adjustments : Huge/Saturation). On the upper layer, add highlights and details such as the necklace, the gem on the choker, and the reflections in the glass. Add little highlights to the fishnets and to her arms and face.

Finish rendering the light on the dress and the rest of the figure. Hit a highlight on the edge of the glass, then create a flare atop that highlight by crossing two Airbrush lines.

VAMPYRA

SHE FLIES DOWN ON HER FLESHY BAT WINGS, DEADLY beautiful. You only get a chance to glimpse at her before she swoops in for the kill. Finished with her victim, she retracts the wings into her back and rejoins the humans, a predator amongst us.

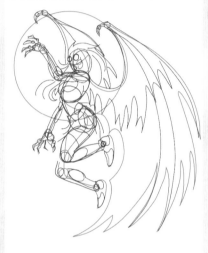

1 Capture the Personality Through Movements in a Gesture Sketch

Vampyra should look like a creature of the night, waiting to strike her next victim. The gesture should evoke tension. Her body forms a zigzag. She's pulling her arm back, considering her next move. Her legs are pulled up. (Think of the way a bird looks when it pulls up and back.) The upper part of the body pulls back, and the part of her back where the wings attach moves under to support the upper body.

2 Construct the Figure

Tilt her head down so that she's looking menacingly over her arm. As her back curves, the front of her body thrusts into a stretch, her rib cage tilted back and up. Her hips tilt forward and down. Indicate the major joints with circles and begin to connect them together.

Refine the relationships between the different shapes of the figure and add clothing and other details to the structure.

Composition

The wings swoop up from the lower right-hand corner, around the figure and up to the circle of the moon. This guides the viewer's eye right up to Vampyra's face. Also include an implied crescent for the second (back) wing.

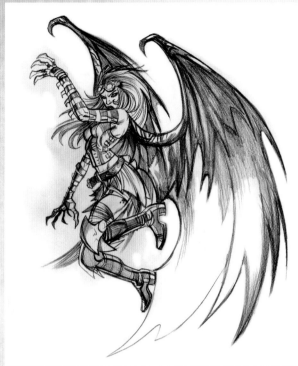

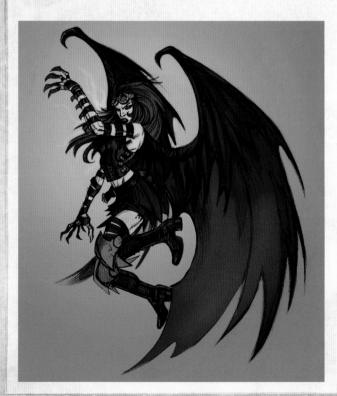

3 Finish the Pencil Drawing

Erase the structure drawings and begin to render the figure with a 3B pencil, adding shading and darkening important lines. Add textures to the wings. Indicate underlighting in addition to the rim light from the moon behind. Since I'm completing the piece on the computer, I decided not to ink the drawing.

4 Tint the Drawing and Color the Arm

Scan the drawing. Duplicate the Background layer and rename the new layer "Drawing." To tint the drawing, select Image menu : Adjustments : Photo Filter and choose Violet as the filter color. Set the Density to a setting you think looks good, and leave Preserve Luminosity checked. Next, use Image menu : Adjustments : Hue/Saturation to lighten the Drawing layer so that the violet doesn't end up being too dark in the final image.

Using the Lasso, select the raised arm. (Tip: For greater control, hold down the Option key [PC: Alt]. This allows you to stop and restart drawing without losing continuity.) Use Image menu : Adjustments : Hue/Saturation to add a skin color. Deselect the arm.

Now, paste in a purple wash you scanned in earlier (see "Build a Digital Texture Library," page 42). Rename the pasted layer "Color Shapes" and put it beneath the Drawing layer. We'll paint over the purple eventually, but we want some purple coming through the entire figure.

5 Establish Midtones

At this point, you can take the piece in one of two directions. You can finish applying colors by selecting areas and filling them with flat color using the Paint Bucket and eventually end up with flat colors in the style of comic-book art. Or you can continue adding textures and more color on top of the piece for a painted effect. To get the painted effect, follow the next steps.

First, use the flat coloring method to apply red for the wings and skirt; use a dark blue-gray for the boots, belt and clothing.

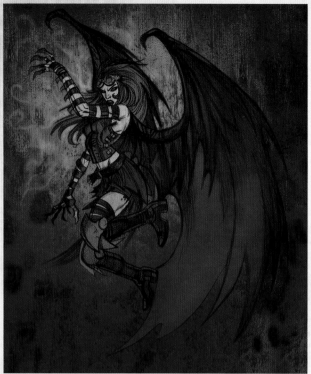

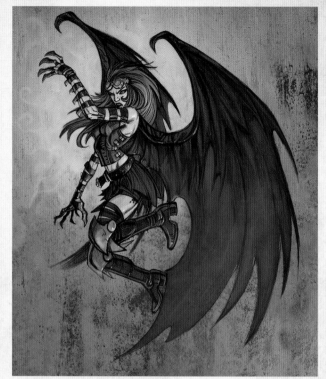

6 Add a Textured Background

Now that you've applied all the colors, add a pervading texture. Paste in a texture you scanned earlier (see "Build a Digital Texture Library," page 42). Give this new layer a name and put it below the Drawing and Color Shapes layers. Change the Drawing and Color Shapes layers to Multiply mode. Lower the opacity of the Color Shapes layer so that you can see the textures through the drawing.

7 Establish Lighter Opaque Color Areas

Create a new layer with a layer mode of Normal on top of all the other layers. Set the Brush tool to a low opacity and add lighter tones to the skin, hair, goggles and wings. Vary the brush size and opacity to create different levels of color intensity around the image. Add color lightly at first, then get more and more intense until the colors are solid and bright.

I had a lot of fun trying out different effects for the background. The beauty of computer painting is that you can change things at any moment. I used the Color Balance Adjustment (Image menu : Adjustments : Color Balance) to add more yellow and cyan to the background color. Since the figure color layers are not 100-percent opaque, the cyan and orange can be seen through them, affecting the color of the entire piece.

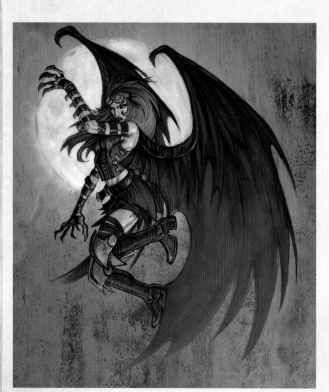

8 Add the Moon

Create a new layer and name it "Moon." Use the Elliptical Marquee tool to select a circle for the moon. (Tip: Hold down the Option key [PC: Alt] to select a perfect circle.) Airbrush blue-grays on the moon to add texture. Put the Moon layer between the bottom layer and the upper layers and change its layer mode to Overlay. The moonlight affects the colors on the figure, so use the Airbrush tool to add some cool highlights to the figure as well.

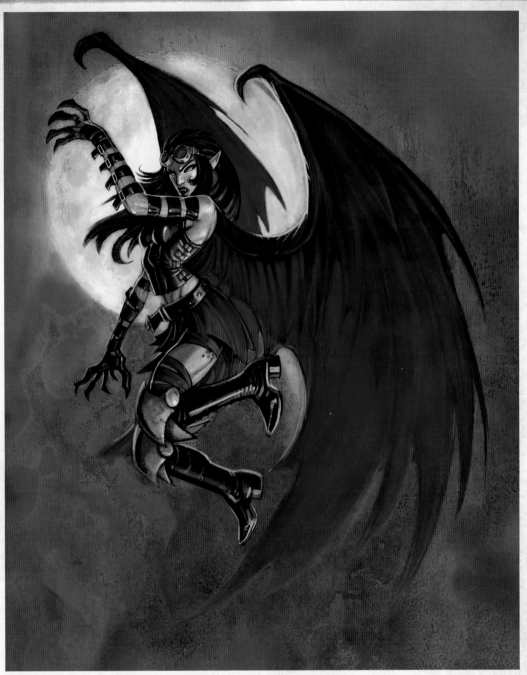

Complete Highlights and Finishing Touches

Retouch the darks with the Airbrush or Chalk Brush and add more highlights in the lighter areas. Use the Airbrush to add black and highlights to the clothing to intensify the contrast and make it look more like shiny patent leather. This makes her look more threatening and intense. Using the Airbrush tool at low opacity, add highlights to the eyes, metal and cloth areas. Add light coming around from the moon in the background with an edge or rim light on all the objects. By darkening the background, the highlights will seem more intense. I decided the hair style was too big, so I changed it here by painting over it on a new layer.

I wasn't happy with the overall gray quality of the piece. Using Image menu : Adjustments : Color : Balance, I intensified the color and added details. I increased the intensity on the reds and made the piece more blue. I got rid of most of the orange but left some remnants there to keep interest in the color.

Heavy Metal Highlights

Make the metal and leather highlights hard-edged and bright so the surfaces look shiny. Highlights on skin will be lower in contrast and blend in more.

RiPPeR, THE PuNK VAMPiRE

HUNTING IN THE NASTY INNER CITY, THE PUNK VAMPIRE IS OUT of control, a modern day monster with no fear. He fights any restrictions the older vampires might try to impose. He's not afraid of humans, not even vampire hunters. Body piercings, tattoos and other violations of the flesh don't bother his cold, dead skin. He enjoys the taste of fear in the blood of his victims. He belts out a hyena-like laugh as his victims attempt to run away in vain. He is a killer, pure and simple, and he loves it.

STUFF YOU NEED

DRAWING SUPPLIES
pencils, eraser, drawing paper, photocopy paper for sketches

OTHER SUPPLIES
scanner, computer, photo-editing software, reference photos of 1970s' punk scene

1 Capture the Personality Through Movements in a Gesture Sketch

The gesture drawing should be aggressive and threatening. Try moving your hand quickly, with harsh lines. Think of the essence of the character as you draw.

Draw the vampire in an aggressive hunch, ready to spring. Focus on the curving movement of the spine, a backward C shape that goes down to the ground. His head is down and forward, and his hips are back. Place the feet apart. Positioning the legs incorrectly will make the punk look as if he's going to fall over. Draw one leg higher and in front of the other to increase the sense of forward movement.

2 Construct the Figure

Draw a circle for the head and an oval for the hips. Draw the center lines for the hips and the face straight up and down. Add big circles for the shoulders, elbows, knees, hands and feet.

After you have the basic framework, begin fleshing out the areas between and around the circles and ball joints. Review the anatomy section (pages 20–27) to see how the muscles and basic body masses fit together.

Begin choosing the important shapes and lines for the final drawing. Erase the lines you don't need.

Composition

Since this is just a figure without much background, the placement on the page is the most important compositional consideration. I placed the figure down and to the right, leaving some white space in front of the creature's face. If I had placed him to the left, the composition would appear crowded.

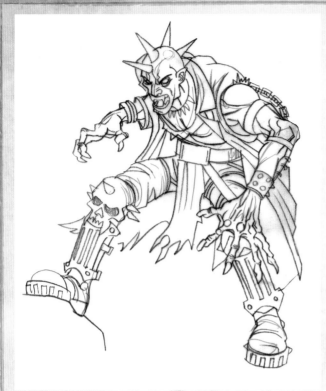

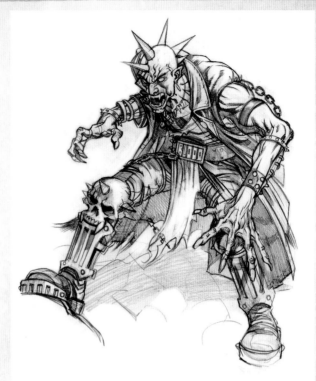

3. Finish the Pencil Drawing

Look up some images from the late-1970s punk scene. Think buttons, big boots, leather, metal plates and spiked hair. The "liberty spike" mohawk on our punk is really just cone shapes attached to the head. The clothes should look like they flow over or fit on top of the body.

The light source is in front of the figure, above and to the right. This means that anything that is blocked from the light will recede into darkness. Refine the pencil lines, erasing stray lines and darkening important lines and areas.

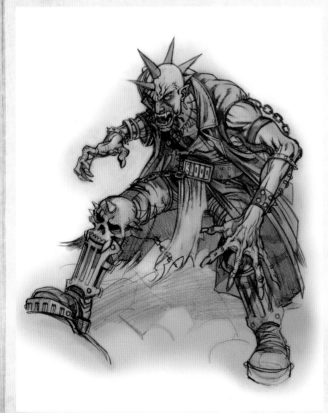

4. Scan the Drawing and Add Color Wash

Scan the drawing. Duplicate the Background layer. Name the new layer "Drawing" and set its layer mode to Multiply. Click the Background layer in the Layers window to make it the active layer, then delete the contents of the background. You now have a pencil layer on top and a blank layer below.

Choose a neutral brownish gray-blue and the 200-pixel Airbrush and begin to lightly airbrush the Background layer. Keep the brush opacity low so you can build color gradually. Airbrush in and around the figure; you want to accentuate the detail areas by keeping them light, and make areas with less detail recede into the dark. Using the pencil drawing as your guide, darken under muscles, folds and facial features.

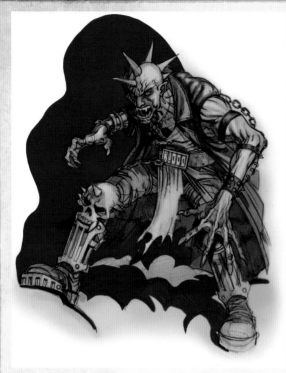

5 Add Color Blocks

Choose three subdued colors and use the Airbrush set at a low opacity to color major areas of the figure. Paint more heavily in the shadow areas. Everything should feel dingy and gray at this point.

To set off the figure and anchor him on the ground, create an abstract dark shape behind him using the Lasso and selecting Image menu : Adjustments : Hue/Saturation.

6 Add Texture and Highlights

Scan a watercolor texture (see "Build a Digital Texture Library," page 42) and lay it underneath the Drawing and Background layers. Set the Background layer to Multiply mode so the texture shows through all the layers. Lower the opacity of the Background layer so the background shape blends in more.

Establish the opaque highlights on a new layer ("Opaques") above the other layers, using the opaque Airbrush or Chalk Brush. Don't go with 100-percent opaque white. You want the option to vary the strength of the highlight.

Add reflective light highlights to the shadows so you don't lose the detail. Reflective light in this case is an orange light from a roaring fire that we can't see in the picture, and the main light is a blue-white street lamp.

7 Reestablish Darks and Brightest Highlights

After adding opaque lights you might find that everything is getting too light. Create a color layer ("Darks") underneath all the other layers to darken and unify everything. Use the same airbrushing technique as in the Background layer. As long as you keep this layer below the Drawing and the Opaque layers, the pencil darks and opaque lights will float above the Darks layer and the figure will appear to come out of the darkness.

The colors should be all set, so you can start dropping in the brightest highlights. Place highlights on the teeth, eyes, cheekbones, brows, elbows, the forward hand's knuckles and any of the clothes that might be shiny (anywhere the objects will be reflecting a lot of light).

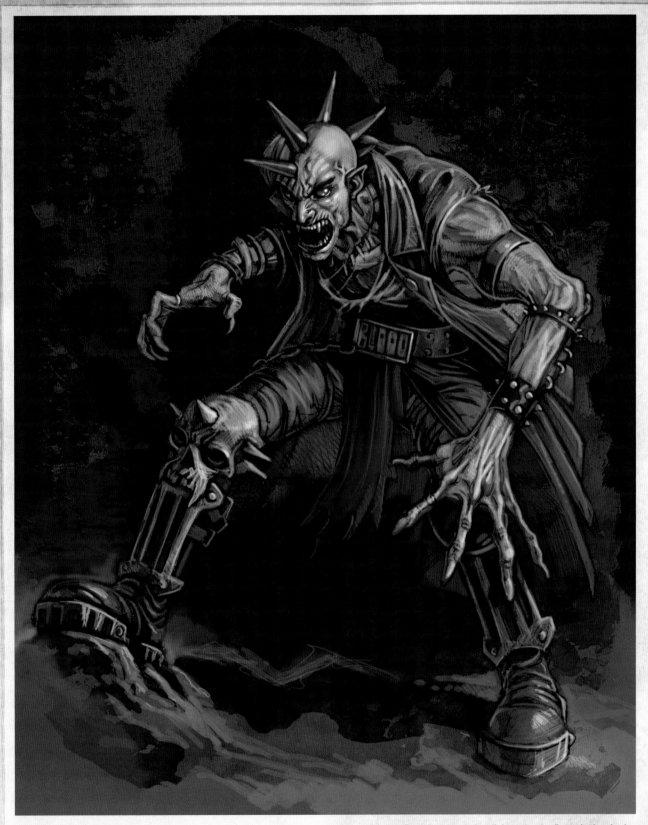

8 Add Final Details

Give the piece more depth by darkening the background. Choose areas that were previously blue-gray and adjust them darker. Add an orange glow around his right foot. This fire glow justifies the orange reflected lights we added to the figure earlier, and it intensifies the sense of threat. Dash in orange glow lights over the figure in the shadows where the body turns toward the glow, the far side of the lip, the edge of the boot, and the chest and arms. Dash in more white highlights as well. Don't make the reflected lights as bright as the highlights.

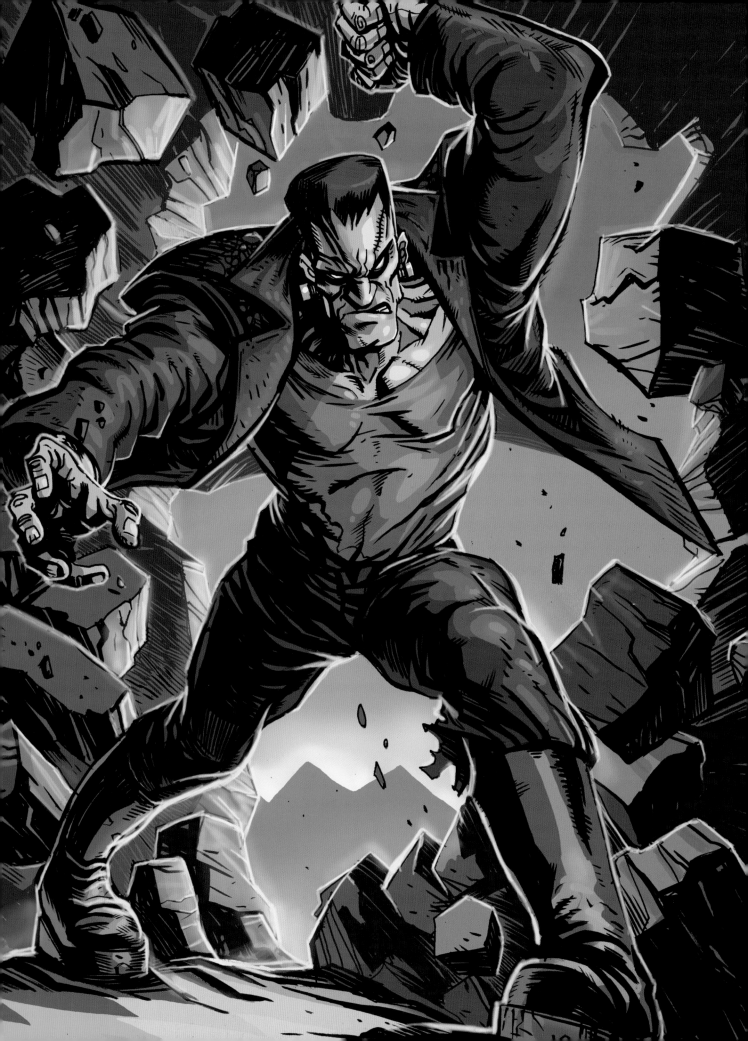

MONSTERS!

MONSTERS! FRANKENSTEIN, MR. HYDE, THE WOLF-MAN—THESE BRUTES LUMBER OUT OF THE DARKNESS. Some were created by mad scientists in hilltop labs, while others are the product of a cursed family bloodline. No matter their origin, they are ferocious killing machines, bent on destruction and death!

JEKYLL AND HYDE

DR. HENRY JEKYLL WAS A PROMINENT SCIENTIST AND DOCTOR

in Victorian England. He sought to unify the dual personalities

within humans: the side we reveal to others and the darker side we keep deep

within ourselves. The result? A formula that tapped into his more primitive side and merged it

with his exterior self. Little did he know that the formula would change him into Mr. Edward

Hyde, a contemptible, murderous creature, barely human, practically a monster. He's

everything that Jekyll is not: vulgar, ugly, loud, brash and strong. Oh yeah, and evil.

STUFF YOU NEED

DRAWING SUPPLIES
pencils, pens, brushes, black drawing ink, drawing paper, photocopy paper for sketches

OTHER SUPPLIES
jars for mixing, reference photos of Victorian-era clothing, toothbrush, white gouache paint

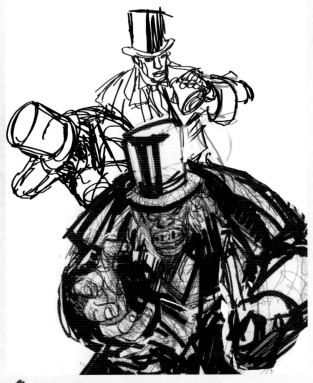

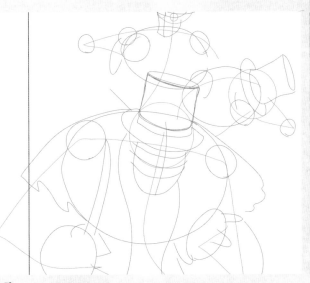

1 Draw a Thumbnail Sketch

Before starting the first gesture sketch, I did a quick thumbnail to see what I wanted from the image. I drew the three figures on three separate pieces of paper, which I then composited together after scanning them into the computer. The characters don't fit together exactly yet, but I placed them so I could get an idea of where everything would be in the final piece.

2 Capture the Personalities and Movements Through a Gesture Sketch

Here's an opportunity to play around with different emotions through pose. Jekyll, a gentleman, stands up straight, with his head and shoulders back (he has the kind of posture your teacher always bugs you about). Hyde is a brute, with his shoulders hunched, long arms reaching to the ground, and unkempt hair falling in every direction.

When creating gestures for these characters, consider their personalities. Jekyll should have a straight, almost stiff gesture, whereas Hyde's should be more wild, hunched and creepy. Use straight lines for Jekyll and lines that curve downward for Hyde.

Composition

Three figures demand a triangular composition. In this case, we'll work with triangles within a triangle. Start with the figure of Jekyll on top. The relationship between his head, far shoulder and the potion bottle makes a triangle, emphasizing the relationship between Jekyll and his potion. The triangle for the transforming Jekyll is formed by his head and arms. The Hyde character has a triangle between his hands and face.

The fourth triangle encompasses the entire piece. Its base is Hyde, with Jekyll at the top, reinforcing the idea of Hyde as a base creature and Jekyll as a gentleman at the height of society.

3 Construct the Figures

Jekyll should have an average build and fairly regular proportions, while Hyde should be larger and hunched. When building the figures, use broader, rounder shapes for Hyde, and straighter, thinner shapes for the Doctor.

4 Refine the Pencil Drawing

After you've finished the basic drawing, start thinking about lighting. I chose to light this scene from the lower left-hand corner. Because Dr. Jekyll is looking down toward the light, his whole face is bathed in clear light. Hyde is turned away slightly, so the left side of his face has heavier shadows. His face is craggier, so the backside of each wrinkle gets a shadow, too.

This kind of lighting also makes drawing the cloth easier. Oddly shaped alternating stripes of dark and light define the folds of the cape.

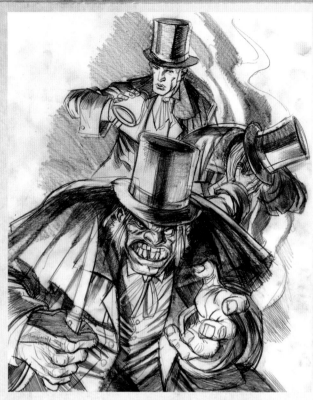

5 Finish the Pencil Drawing

After you've established the dark areas, add more textural details in the midtone and light ranges. For costuming, use old styles from the Victorian era, such as a top hat, cravat, vest and large coat. A simple Internet search or a trip to the library will get you the reference photos you need.

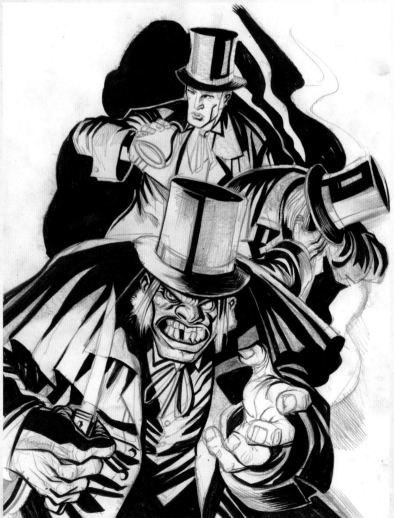

6 Ink the Drawing and Add Spatter

Use your brush and black ink to create solid black shapes anywhere there's a shadow shape. Don't think about line yet.

Now use your brush or pen to go over the lined areas. At first, just follow the lines you laid down to complete the structure. Then add flourishes with the ink brush. Create textures by hatching and crosshatching with either the pen or the brush.

Next, fill a toothbrush with white gouache and spatter the piece (you might need to first wet the toothbrush so the paint flies better). Drag your thumb across the bristles; you'll end up with a white thumb and some cool-looking spatter. Be careful not to do too much—it's hard to undo.

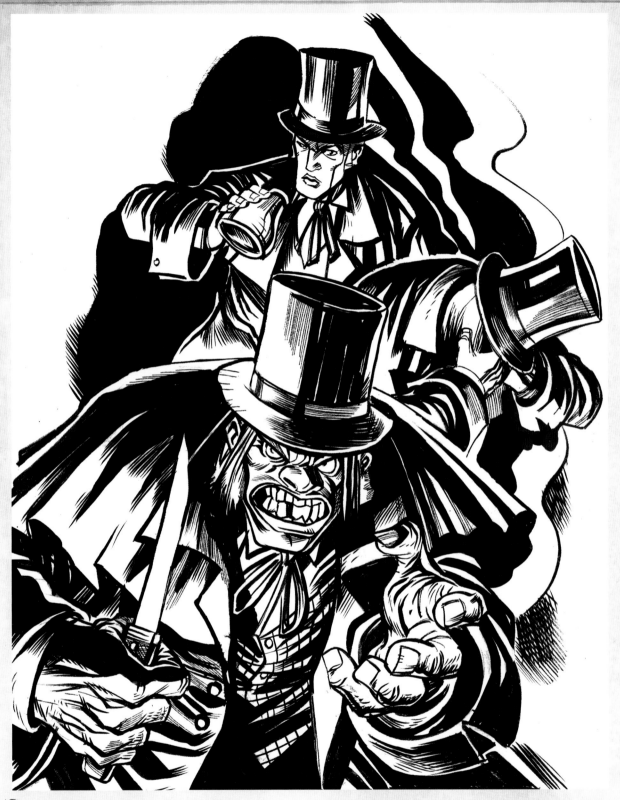

7 Add Final Details and Evaluate the Final Piece

Trace over the lines, render the shadows and add texture. As a general rule, the lines that define shading point like tiny arrows from the shadows toward the light. As you can see on Hyde's cloak, the lines begin in a black shape at the top of his shoulder and glide down toward the light source, dwindling from thicker lines to thin to nothing. Don't let rendering lines like these interfere with the primary construction lines that create the forms. Create textures such as those on Hyde's hairy hands with dashes. Keep these texture lines secondary to the shading and construction lines so they don't confuse the drawing.

MARY SHELLEY'S FRANKENSTEIN

THIS IS NOT THE GREEN CARTOON MONSTER, THIS IS THE creature right out of Mary Shelley's *Frankenstein: The Modern Prometheus*, the first horror novel ever written. (It's an intense piece of literature and will score you major points with your teachers if you can discuss it intelligently.) The Monster in *Frankenstein* is articulate, intelligent and lithe, and he's angry with his creator for rejecting him. In this picture, he is crouching in the mountains, waiting for the right moment to exact his revenge.

Shelley described him best: *His hair was of a lustrous black, and flowing; his teeth of a pearly whiteness; but these luxuriances only formed a more horrid contrast with his watery eyes, that seemed almost of the same colour as the dun white sockets in which they were set, his shrivelled complexion and straight black lips Oh! No mortal could support the horror of that countenance.*

STUFF YOU NEED

ACRYLIC PIGMENTS
Cadmium Orange, Cadmium Red, Cadmium Red Medium, Cadmium Yellow Medium, Cerulean Blue Deep, Mars Black (or ink), Payne's Gray, Titanium Buff, Titanium White, Ultramarine Blue, Ultramarine Blue Light, Van Dyke Brown

DRAWING SUPPLIES
pencils, eraser, charcoal or graphite (if not scanning sketch), black drawing ink, sepia ink, bristol board, photocopy paper for sketches, 3-ply watercolor paper

OTHER SUPPLIES
scanner, computer, photo-editing software, spray sealant, jars for mixing, tape, wooden board or solid surface

Composition

We're creating a falling composition. The mountain at the upper left leads your eye into the picture, through the figure, then through the monster's face and hand, down to the mountain, and out of the page through the opposite corner.

Within the piece, the creature's hand with the highlights at the wrist points right into the face, bringing the attention where we want it. The torso and legs are less important compositionally except to act as a dark base for the light figure area to rest upon.

1 Capture the Personality Through Movements in a Gesture Sketch

Use the mountains to create a sense of space that implies loneliness. Draw the gesture with a lot of tension (think of a rubber band held tightly, ready to release). Every line of the gesture should work against the last line. The shoulders are angled to the hips. The head turns slightly downward so he's looking at us through his eyebrows, increasing the menace.

2 Construct the Figure

The Monster was created by a human, assembled from multiple bodies, so something's going to look wrong. The parts may be out of proportion to one another, and some of the muscles are twisted as if they were attached strangely. This doesn't mean you can ignore anatomy. Your monster will be far more believable if you draw realistic anatomy, then twist it a bit. Pay close attention to the shoulders and arms since they are in the light and need to be drawn more carefully than the lower half of the body.

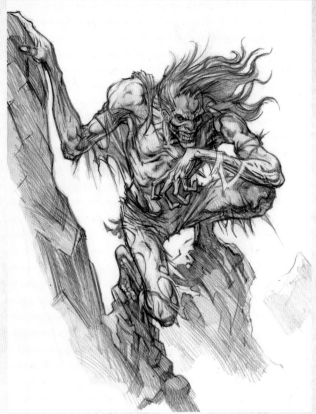

3 Refine the Pencil Drawing

Work with shadows and bring the lit areas forward. This piece has strong lighting contrast (it's lit by lightning from above left). Lighten the shadows as they get farther from the light source. This will imply an atmospheric light that is reflecting off the mountains and back onto the creature. Don't just draw black shadows—add details. To make the stone believable, change the direction of your shading and vary the textures. Draw ripped clothes wrapped over the arms and legs.

4 Finish the Pencil Drawing

Tighten the shadows. Add little highlights in the shadows to mimic reflected light from the fires below and to the right. Refine and clean the edges and smudges. Use an eraser to pull out the highlights.

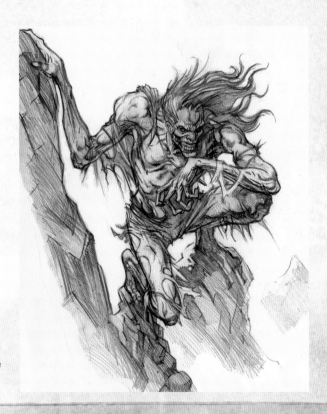

5 Tone and Transfer the Drawing

I want subtle effects in the shadows, and absolute blacks would make the piece too harsh, so we're going to skip the inking. Scan and tone the lines brown and give a subtle brown to the background. Next, transfer the sketch to a board. Print the drawing on heavy paper stock, such as 3-ply watercolor paper. If you toned your drawing by hand or don't have a printer, take your drawing, flip it over, and use a soft charcoal or pencil lead to cover the back side of the drawing. Flip the drawing over, lay it on top of the board you wish to paint on, and trace over the original lines of the drawing with a sharp pencil. If you press hard enough, the graphite on the back of the drawing will transfer your drawing to the board.

Tape this board to a hard surface to keep the art from bending when you start painting. Spray the image with workable fixative, then tape the board down so it won't buckle.

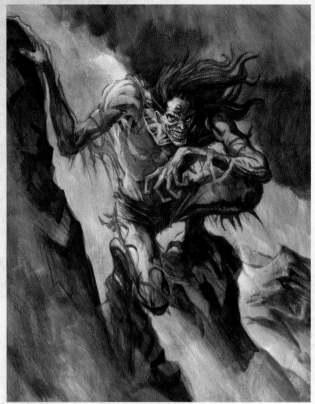

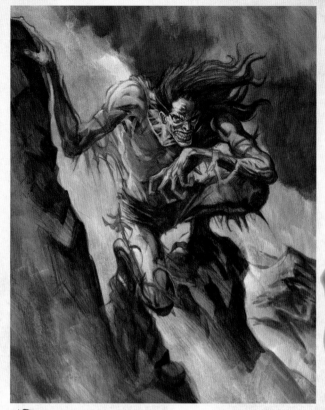

6 Apply a Color Wash

Using a no. 10 flat, wash the painting with diluted Cerulean Blue Deep. The blue will pervade the entire piece. Next, wash Payne's Gray and Van Dyke Brown into the dark areas, keeping the pencil work in those areas intact. Add ink or Mars Black for the deepest shadows. The shadow shapes will hold your piece together.

7 Establish the Midtones

Create the clouds and background sky colors with Ultramarine Blue, Payne's Gray and Titanium White. For Frankenstein's pale, dead skin, mix Titanium Buff with a bit of Ultramarine Blue and Payne's Gray. Mix Titanium White and a bit of Titanium Buff for the highlights. Add a little blue to the skin with Ultramarine Blue Light. For the warmer tones, in the foreground, use Cadmium Red Medium and Cadmium Orange. For hot areas of the skin, nose, ears and around the eyes, add Cadmium Red to the flesh tone mixture. This gives the skin a bit of a glow. Apply Cadmium Yellow Medium around the eyes only for a bright focus.

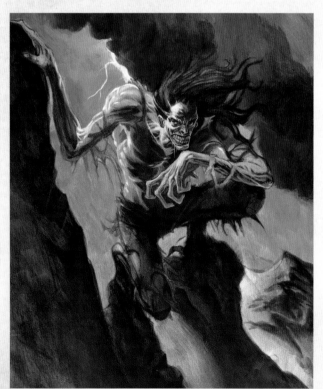

8 Establish the Darks and Edges

Using a darker blue (almost black), lay in the darkest shadow areas and create the interplay of light and dark.

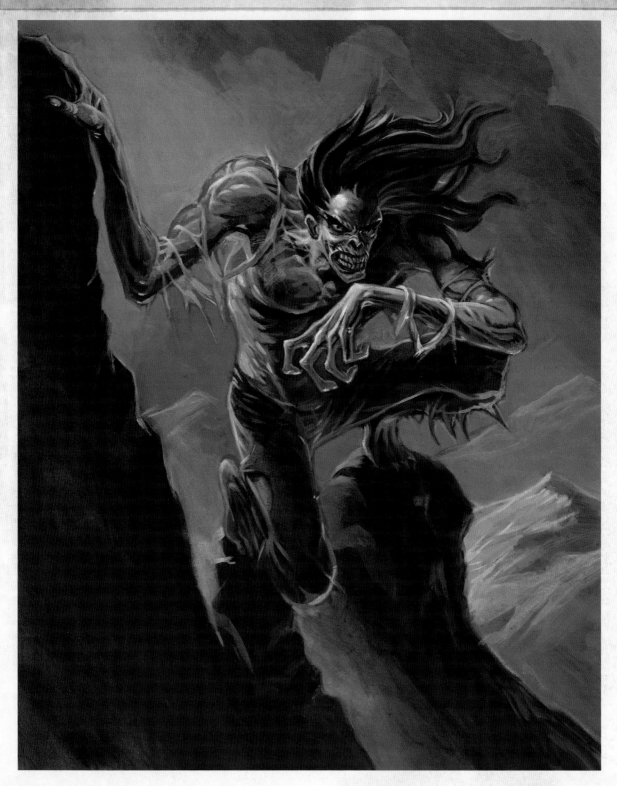

9 Add Highlights and Final Details and Evaluate the Final Piece

Start adding blue highlights from the sky, and the orange glow from below. The highlights will be in the middle of a rounded object, not on the edge, just like a lit ball (see pages 16–17). The lightest darks will never be the same value as the darkest lights. If it's in the light area, it will always be lighter.

After the figure is finished, it's sometimes necessary to replace the background colors around the figure to sharpen the edges between the foreground and background. Make sure the background color is darker than the lighter areas and lighter than the darker areas of the figure. Otherwise, you won't be able to tell where one ends and the other begins.

Refine and clean up the piece, making sure your values are separated and your highlights are defined and sharp.

FRANKENSTEIN'S MONSTER

HE'S BIG, STRONG AND MISUNDERSTOOD. HE WAS MADE IN A lab by a mad scientist with a weird little assistant named Igor. You guessed it. It's Frankenstein's Monster. This is the classic, movie-monster Frankie: He can't run, he can't really use his arms very well, he lumbers around breaking things, and all he can say is, "Grrrawwwww!" No wonder those villagers wanted him dead! To show off his amazing brute strength, let's depict Frankie taking out his ire on a stone wall. He's escaping the lab and he's angry.

STUFF YOU NEED

DRAWING SUPPLIES
pencils, eraser, quill pen or technical pen, brushes, black drawing ink, drawing paper, photocopy paper for sketches

OTHER SUPPLIES
scanner, computer, photo-editing software

Composition

Setting the ground at an angle creates tension and sets the viewer off-kilter. Make the hole in the wall almost circular. The monster breaks the circle, giving the impression that he's busting through the wall. His figure is basically X-shaped. His feet are planted; he's not going anywhere he doesn't want to go. Throw the stones around, but not too randomly. Try to place them so they highlight a part of the monster without covering him.

1 Capture the Personality Through Movements in a Gesture Sketch

This piece requires a sense of movement, but it's not smooth. His arms should look as if they've just broken through the wall. Bring that front leg far forward to push the breaking-through idea. Bring the opposite arm forward to highlight his strength and give the impression that he's moving at us.

2 Construct the Figure

You can draw the upper and lower torso as one big shape, accenting his mass. Build the arms off of the torso. After they're in place and you've decided their tilt and positioning, draw out the limbs. Keep in mind the secondary points on the body (elbows, wrists/hands, knees and ankles/feet). These are important landmarks for positioning the body.

3 Refine the Pencil Drawing

Pay special attention to the forward hand and its construction. Start with a wire frame to capture the movement, then block in the fingers in small segments before rendering them. There is nothing worse than an object that is nicely rendered but badly constructed, so pay close attention to the anatomy. Next, lightly place the shadows for the entire piece. Use the shadows as counterpoints to points of interest. Use strong light/dark contrasts to draw attention. The front leg is a good example of this. The dark blocks behind the leg move it forward into the light.

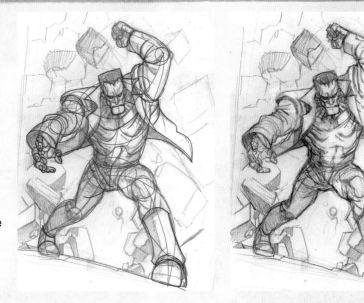

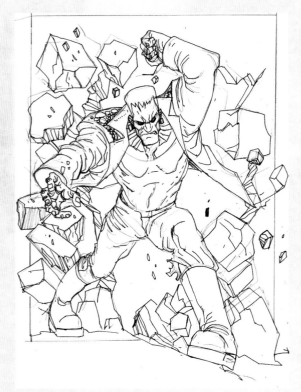

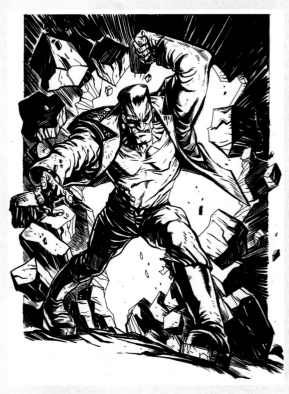

4 Finish the Pencil Drawing

Clean up your drawing. Don't worry too much about textures. We're going to ink it, so the extra pencil marks would just cause the ink to resist. I've removed a lot of the shading so that I can ink it more easily.

5 Ink the Drawing

Using brush and ink, recreate the lines from the pencil drawing. Because ink doesn't give you the luxury of using gray tones, you have to rely simply on black and white. Create gray tones by adding black textures to white areas or white textures to black areas. This way the art won't seem too flat. Use angular lines for the stones, softer linework for the clothes, and even smoother lines for the skin. I like to include white lines cutting through the shadows of an object in the direction of its movement. If the stones were solid black, they'd feel heavy and unmoving. The lines breaking up the shadows make the stones look as though they're hurtling forward.

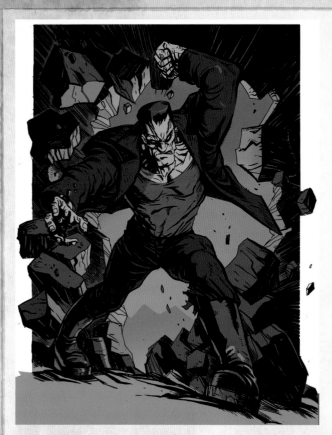

6 Scan the Drawing and Add Color

Scan the drawing. We'll start by laying in flat tones on the computer, breaking the image into color areas rather than coloring the details. First, copy the ink art onto a second layer. Name this layer "Inks" and change its mode to Multiply. Next, switch to the Background layer, select all, and delete to white. Using the Lasso tool, select areas and fill in the shapes with flat color using the Paint Bucket tool. Think about the largest pieces of your color composition. In this case, I chose cool colors for the background and warm colors for the figure and foreground. Select the head, chest and shoulders and drop in a green. I decided to go with an olive hue for the skin (rather than bright green) so he doesn't look like candy. Continue shape by shape. The clothes are somber browns and grays, and the background is a light cool blue to contrast the dark interior.

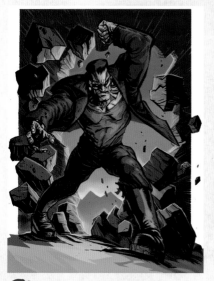

7 Continue Rendering With Flat Colors

On a new layer under the Inks layer, add abstract shapes in lighter tones of the established background colors. The darkest shadows are already created by the black ink. To more fully render the dark brown coat, add a lighter brown shape. Add second and third levels of lighter-colored shapes over the background color to create a more rendered look. Stick with the warmer interior colors on the figure, floor and interior rock shapes.

8 Knock Back the Background

Go to the Inks layer. Using the Polygonal Lasso tool for better control, select the black area that makes up the back wall of the castle. Avoid selecting the flying rocks. Use the Paint Bucket to fill in this area with dark grayish purple (a paler purple would be too intense and interfere with the foreground colors).

9 Add the Exterior Backlight

Add a cool, exterior, backlight of pale blue around the mountain at the horizon. Use the Airbrush to draw thin, medium-opacity lines on the edges of the hole Frankie just burst through. Add some of these lines to the rocks facing the hole where the pale light is emanating. Add some larger areas of pale blue to these rocks. Notice how this pushes Frank forward out of the background.

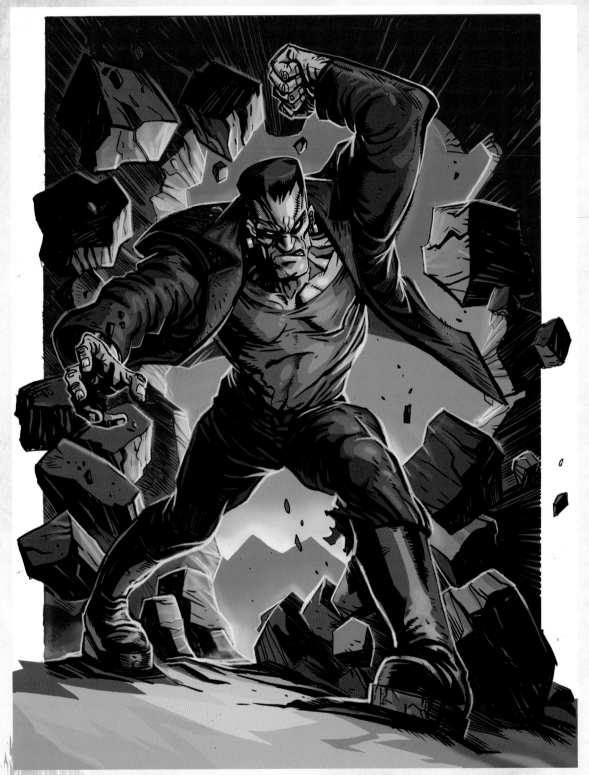

Highlighting Tip

Be careful adding highlights. Use highlights in areas of focus only. Also, be aware of the texture of the object you're coloring. Metal, such as Frankie's neck bolts, has very bright, high-contrast highlights, whereas the monster's dirty old coat will have less contrast. Put highlights on his face and on the forward hand and leg to bring these areas into focus.

10 Outline the Figure

Using the same technique as in step 9, add blue edges to Frankie (outside edges only). The temperature contrast provided by this cool edge of color will make the warmer greens and browns pop forward, making Frankie really look as though he's bursting through!

WITCH

THIS IS THE EVIL WITCH FROM THE OLD STORYBOOKS. SHE cackles wildly over her cauldron, waiting for small children to cook in her stew. Her decrepit house is filled with ancient tomes, skulls and ingredients for her horrible creations.

STUFF YOU NEED

DRAWING SUPPLIES
pencils, eraser, drawing paper, photocopy paper for sketches

OTHER SUPPLIES
scanner, computer, photo-editing software

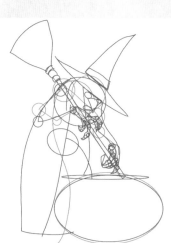

1 Capture the Personality Through Movements in a Gesture Sketch

The old witch holds most of her movement in her arms and hands. The curve of her back comes from the back of her head, down to the ground. The arms angle out from her shoulders to grab the broom. Her fingers and wrists curve around the broomstick.

2 Construct the Figure

The rags drape straight down from the back of her neck and shoulders and avoid the curves of the body, so it's important to block in her shoulders accurately.

Use basic shapes to construct her face. Her face is an upside-down triangle, as is the nose. The eyes are ovals. The angle of the front arm is a triangle. Her hat is a triangle and the brim is a disk. Start the hands with circles for knuckles and wrists.

Composition

Build the witch with a series of circles and triangles. The main triangle is the body of the witch, running from the top of her head to the ground. Add a circle for the head. The pot is another circle that blocks the front of the body triangle. The triangle of the broom head points down to the circular pot, then the pot's upward glow guides your eye to the witch's face. A triangle for the witch's right arm takes your eye from the back of the witch's head to her elbow, to the wrist then back to the head.

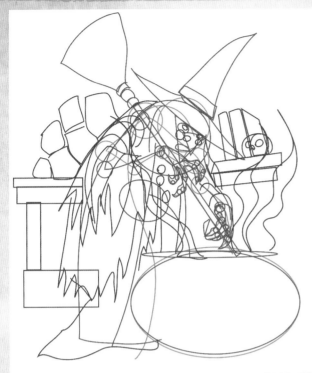

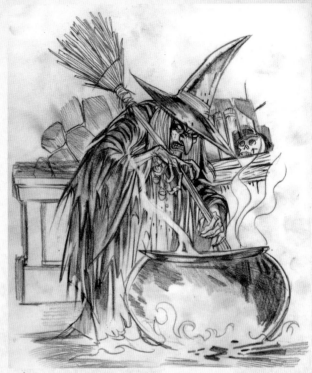

3 Refine the Pencil Drawing

Add details and draw connective lines between the different sections, filling out the figure of the witch. Cut sharp triangular pieces into the robes to make the ends irregular.

4 Finish the Pencil Drawing

Start rendering the textures and tones in the picture. Add character to the lines by varying their weight and length. Render the light coming up from the pot (the main light source) and onto the rest of the image. Anything turning away from the light will be in shadow. The midtone grays will be between the darks and the areas in full light. There isn't much reflected light in this piece.

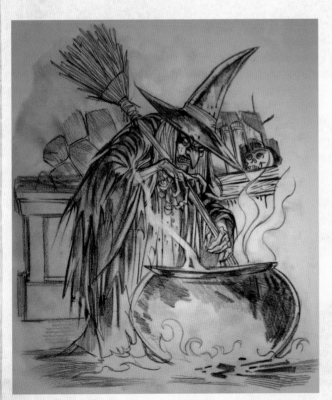

5 Scan the Drawing and Add Color

Scan the drawing. Tone the drawing using Image menu : Adjustments : Photo Filter; choose a nice brown for the filter color. Duplicate the Background layer, name the new layer "Drawing," and set its layer mode to Multiply.

Now create a new layer, name it "Gradient," and place it underneath the Drawing layer. Select a bright whitish yellow for the foreground color and a dark brown for the background color. These will be the colors for the gradient we're about to create.

Choose the Gradient tool (in Photoshop, click and hold on the Paint Bucket tool to switch to the Gradient tool). Click the Radial Gradient shape in the Options bar at the top of the main window. Now, working in the Gradient layer, Lasso the cauldron shape. To create the gradient, click and hold near the center of the cauldron shape, drag out to the edge of the selected shape, and release. The bright whitish yellow will be near the center of the pot, transitioning gradually to dark brown at the edges. Reduce the opacity of the Gradient layer so the effect doesn't overpower the drawing.

6 Establish the Midtones

Add a layer between the Drawing and Gradient layers. Set the new layer to Normal and add color to the face, hat and broom using the Lasso tool. Trace shapes from the Drawing layer (the hat, for example), then drop colors into the shapes with the Paint Bucket. Add some of the deep greens in the background. Put some yellows and lighter colors in the cauldron.

7 Add Texture

Paste in a dark brownish green watercolor texture (see "Build a Digital Texture Library," page 42). Rename this layer "Texture" and place it under all the other layers. Set all the other layers to Multiply so that the watercolor texture shows through.

8 Establish Darks and Add Lighter Opaque Tones

On the Texture layer, select areas such as the hat, robes, the shadow on the wall and the cauldron with the Lasso tool. Darken these areas using Image menu : Adjustments : Hue/ Saturation. This darkening method will retain texture in the darks.

Begin to add the lighter areas, especially around the face, hands and the edge of the pot. The areas farther from the glow of the cauldron should have less or no opaque color.

9 Add Final Details

So far, we've used mostly browns and greens for this piece, with slight touches of red and orange. The lights are all light yellows and yellowish whites. The reds are focused in places where they will act as accents to the greens. As complementary colors, red and green will vibrate against one another. In a mostly green composition, reds draw the eye to points of interest, so they've been mainly reserved for the witch's face and hands. If you look closely, you'll see that I added light reds over the brown robes and the greens in the witch's skin to again draw the eye to that area of the piece. Outside of that area, I have allowed the colors to be more monochromatic.

To finish, use the Airbrush to create the fiery glow around the base of the cauldron, using the pencil lines as a guide. Since this is the main light source, reflect the fire color throughout the piece on any surface facing the light source.

WOLFMAN

HE WAS BITTEN BY A RABID WOLF. NOW, WHEN THE MOON is full, this man begins to change. His hair grows in places he never thought possible, his teeth lengthen, his fingernails become yellow and claw-like. He feels the urge to run in the woods, howl at the moon and eat human flesh. He's a wild beast now, hunting people and animals for the few days when the full moon controls his every move, while his human side fights for control. His horror is the beast overtaking the human. He is forced to watch as he murders his own loved ones.

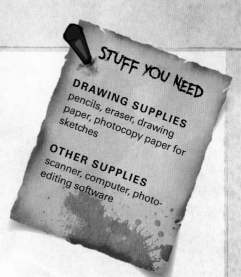

STUFF YOU NEED

DRAWING SUPPLIES
pencils, eraser, drawing paper, photocopy paper for sketches

OTHER SUPPLIES
scanner, computer, photo-editing software

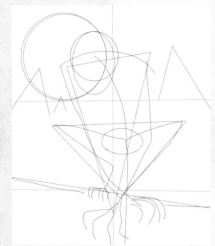

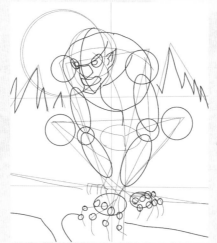

Composition

This composition looks centered, but this is deceptive. The body is centered, but the head tilts and is encircled by the moon, bringing the focus of the piece to the face, which is off-center. The bottom of the composition is cut off by the log that in turn redirects the eye to the center of the piece.

1 Capture the Personality Through Movements in a Gesture Sketch

The wolfman is cunning, perching in the woods waiting to pounce on a victim. He crouches on a fallen tree, his back hunched, his hands down grasping the tree. His head hangs low as he watches.

Start with a circle for his head, arching back and around from the top of his head to the bottom of the spine. Draw a line for the shoulders, then draw the arms, creating the primary triangle of the composition. His knees form the side points of a bottom secondary triangle, and the hands and feet form the bottom points of both triangles.

2 Construct the Figure

Base the body of the wolfman on two upside-down triangles formed by the sharp angles of the shoulders and the knees. The opposing triangles of the trees create a line that zigzags you into the piece from the sides, allowing you to center on the moon and the head. Develop and flesh out the figure with bubbles and circles, indicating the underlying structures of the body. Soften the lines and keep the drawing light so you can draw darker each time you move forward.

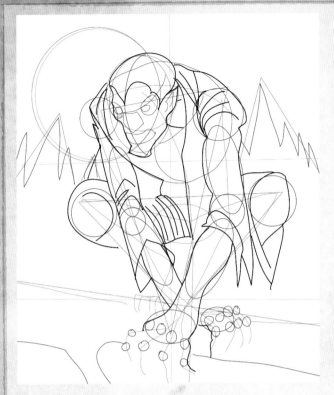

3 Refine the Pencil Drawing

Drape cloth over the body. Select and emphasize the outside lines of the figure, then add hair and final lines to the drawing.

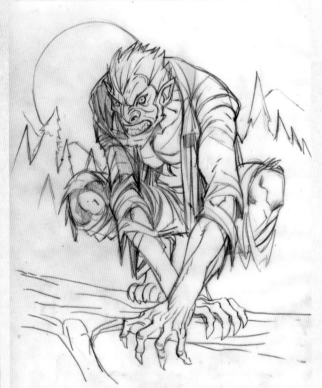

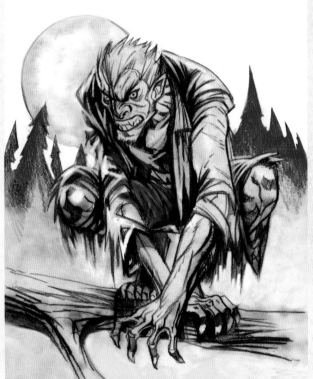

4 Finish the Pencil Drawing

Establish the final lines and begin adding textures. Think about how you can render hair and cloth. Long strokes will give a very different feel than short hatching. Now focus on the background and rendering the light. Think of the shadows as distinct shapes rather than letting them blend too much. In more extreme lighting circumstances, the light becomes even more sharp-edged.

Next Step: Scan and Tint

We're not going to ink this time. Instead, scan the image, duplicate the Background layer, set the new layer to Multiply, and use the Photo Filter to tint the image brown.

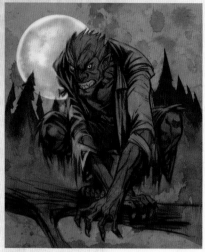

5 Add Color

Paste in a blue texture (see "Build a Digital Texture Library," page 42) and move this new layer behind the pencil layer. On the texture layer, use the Lasso tool to select areas and shift the colors with the Hue/Saturation adjustment, changing the hue and value. Turn the trees green. Select the wolfman's body and turn it brown. Make the shirt gray.

6 Establish the Midtones

Using the Airbrush on middle to high opacity, start adding rim lighting from the moon to the figure. Create the folds of the shirt with the light from the moon cascading over the shoulders and arms of the wolfman.

7 Establish Darks, Edges and Light Opaque Tones

Add the warms and other midtones throughout the entire piece, mostly reddish brown and yellows. Add lighter tones to the shirt, and define the edges of the piece with cool light blues. As you add light tones, you might want to up the contrast and add some darks in deep shadow areas as well. Add some warm yellow and reddish tones from the right side, opposite the light area of the moon.

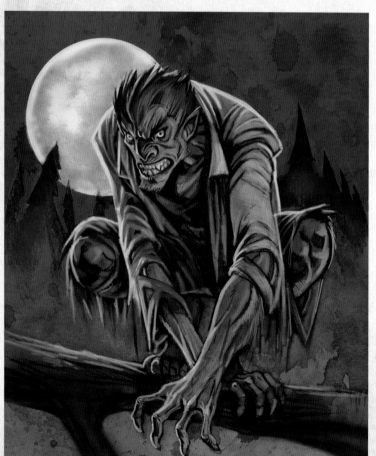

Color Breakdown

The moon will cast a cool tone on the figure from behind. These cool tones will move along the wolfman's right side. There is a warm underlighting coming from the lower right of the piece. All the colors on the moon side will be cooler, while anything lit from the front right will have a warmish glow.

8 Add Darks and Highlights

Using the Airbrush, add some cooler darks to the hair and other edge areas. This makes the temperature contrast a bit higher in the areas between the cool moonlighting and the warm light from the front, making the highlights jump out even more.

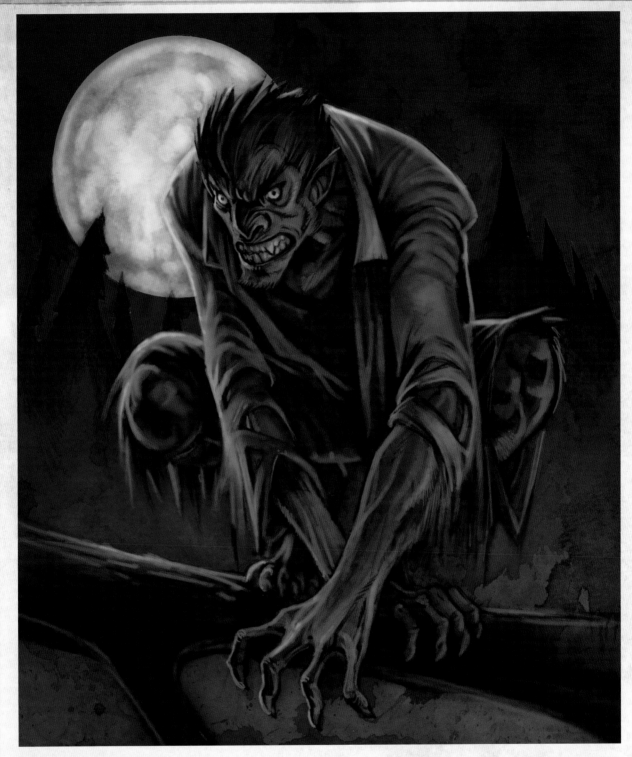

Add Final Details

At the bottom of the Layers window, you'll see a button that looks like a half-white, half-black circle. This button lets you add an Adjustment layer above the active layer. Adjustment layers allow you to alter the color in a layer, yet adjustment layers can be moved, hidden or deleted to instantly remove the alteration.

Make sure the texture layer is active, then click that circle icon. A menu will pop up; choose Hue/Saturation. Darken the color using the Lightness and Saturation sliders. Use the Hue slider to change the color to more of a greenish blue.

Add a new layer with a deep purple fill. Leave this layer on top of all the others and change its mode to Multiply. Erase some of the purple over the lighter areas such as the moon, the edges of the body, the eyes, and the highlights on the shoulders, arms, hands and knees. The remaining purple will create a sense of depth, add richness to the colors, heighten the contrast and give the piece a lot more drama.

DEMONSTRATION
WEREWOLF

IT COMES OUT BY NIGHT, MORE BEAST THAN MAN. THE werewolf is more fully a monster than the wolfman. All traces of humanity have disappeared. It can't control its hunger for human flesh. This monster is fast, furious and covered in fur. Its ivory teeth glint in the moonlight that transformed the werewolf and gives it its power. Beware the woods at night. When you hear a howl, it's too late. The hunt is on!

STUFF YOU NEED

ACRYLIC PIGMENTS
Burnt Umber, Cadmium Orange, Cadmium Red Medium, Cadmium Yellow Medium, Cerulean Blue, Hooker's Green, Payne's Gray, Phthalo Blue, Raw Umber, Titanium Buff, Titanium White

DRAWING SUPPLIES
pencils, eraser, Burnt Sienna colored pencil (if not scanning sketch), photocopy paper for sketches, 3-ply bristol board

OTHER SUPPLIES
scanner, computer, photo-editing software, reference photos of wolves, spray sealant, jars for mixing, tape, wooden board or solid surface

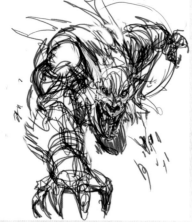

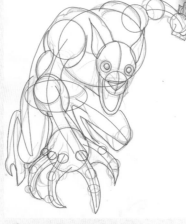

1 Capture the Personality Through Movements in a Gesture Sketch

The main point of this piece is movement. This beast is running full tilt at the viewer, with its claws ready to tear into flesh. There are two arcs: One leads from the head, around and over the shoulders, down the spine to the right knee in a C shape. The other is from the forward hand, up the arm, over the shoulders to the far hand in the distance. These two strong and distinct arcs give the impression of forward movement.

2 Construct the Figure

Add circles to define the basic parts of the figure. The forward hand is extremely foreshortened, so make it much larger in proportion to the figure. Everything in a painting is two-dimensional, so the artist's job is to create the illusion of depth. Foreshortening is one tool to help create distance.

Composition

Draw the moon as an incomplete circle around the werewolf's face, to draw the viewer's attention there. The hand reaching into the foreground draws the eye from the lower left to the face. Everything in this piece is tilted: the moon, the figure, the tree, everything. This creates an off-kilter sense—the kind of feeling you get from running very quickly through the woods with a werewolf at your back.

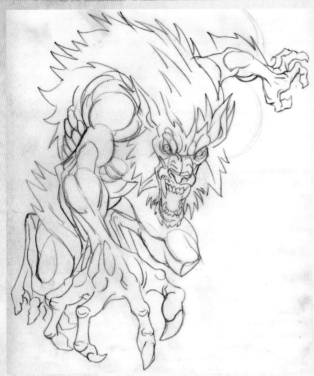

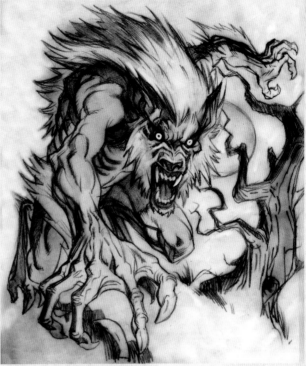

3 Refine the Pencil Drawing

Finish the body, paying special attention to the teeth and eyes. These are the main focus of the piece, so you want them to be the strongest part of the image. Wolves have a distinct way of furrowing up their noses when angry. Use a reference photo to see how to construct the nose and eyes of this beast. The hand is next in importance, so make sure the anatomy is correct.

4 Finish the Pencil Drawing

Focus on the hair. Don't treat it as single strands. Hair doesn't move individually; it moves in groups of thousands. From a distance, we can't even see the strands. Because the hair is part of a group, shade and light it as a group.

You can stop now, or you can complete the following steps to make a color image.

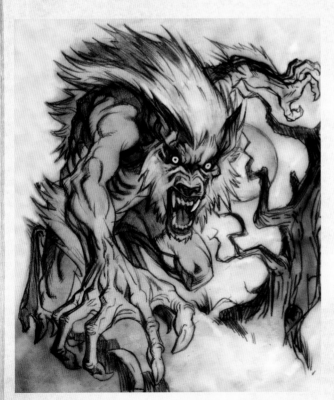

5 Scan and Tint the Drawing

Scan the drawing. Duplicate the Background layer. Name the new layer "Drawing" and set it to Multiply. Use the Photo Filter to tint the drawing brown. Even after you add other colors, the drawing will always have a warmer tint.

If you don't have a printer, start the initial drawing on thicker paper (bristol board), using a Burnt Sienna colored pencil.

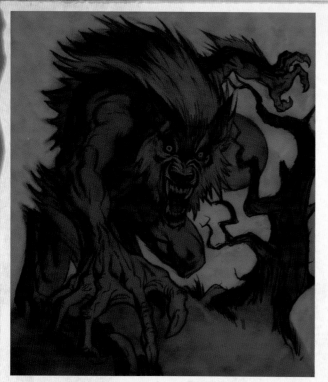

6 Add a Blue Color Wash and Print the Drawing

Now paste in a blue texture layer (see "Build a Digital Texture Library," page 42) underneath the brown-tinted Drawing layer. Lower the opacity of the Drawing layer. This keeps the browns in the piece while allowing the blues to come through. The pencil smudges tint the lower layer with a brown haze.

Now print the drawing on a heavy-weight paper. Stronger, thicker paper with a nice tooth like Strathmore is a great choice. Thinner papers will buckle and look terrible. (If you don't have a printer, tint the entire piece with a Payne's Gray wash.)

Tape the drawing to a strong wooden board or table surface. If you don't, the paper will buckle when you apply paint. If you tinted your drawing with paint (not on the computer), apply spray fixative so the color doesn't bleed. Since the darks and most of the darker midtones were established with the initial blue wash, we now need to add the opaques over top of the darks.

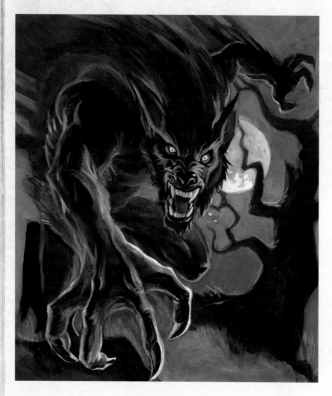

7 Add Color and Texture

Add warm Burnt Umber to the tree and the figure in the shadows to bring a little more color into the darks. Add Payne's Gray to reinforce the shadows. Brush in Cerulean Blue for the sky. The Cerulean's greenish tint will add a nice accent against the cool blue underpainting. Mix Cerulean Blue and Raw Umber for the beast's gray hair. Add Titanium Buff and Titanium White to the mix for the lighter parts. Bring in some Cadmium Orange and Cadmium Yellow Medium for the warmer reflections. Paint the grass with Hooker's Green. Use no. 4 and no. 5 flats to paint the larger areas and refine with no. 1 and no. 01 rounds.

This piece is divided in half between warms on the left and cools on the right. The darkest darks are between the cool blues and the warm oranges. This battle between complementary colors creates intensity.

Paint the eyes with a cool gray-blue mixture of Payne's Gray, Cerulean Blue, Phthalo Blue and Titanium White. Next, add reflected light with a yellow-orange mixture of Cadmium Yellow Medium and Cadmium Orange. Encircle each eye with a black ring, then dash in Titanium White highlights. Add Cadmium Red Medium into the black areas encircling the eyes.

To make the nose look wet, paint the dark areas black, then dab in white on top without blending. Pure black next to pure white creates the highest contrast on the page.

By concentrating all these areas of high color and tonal contrast on the face of the werewolf, you've created a place that naturally draws the eye of the viewer.

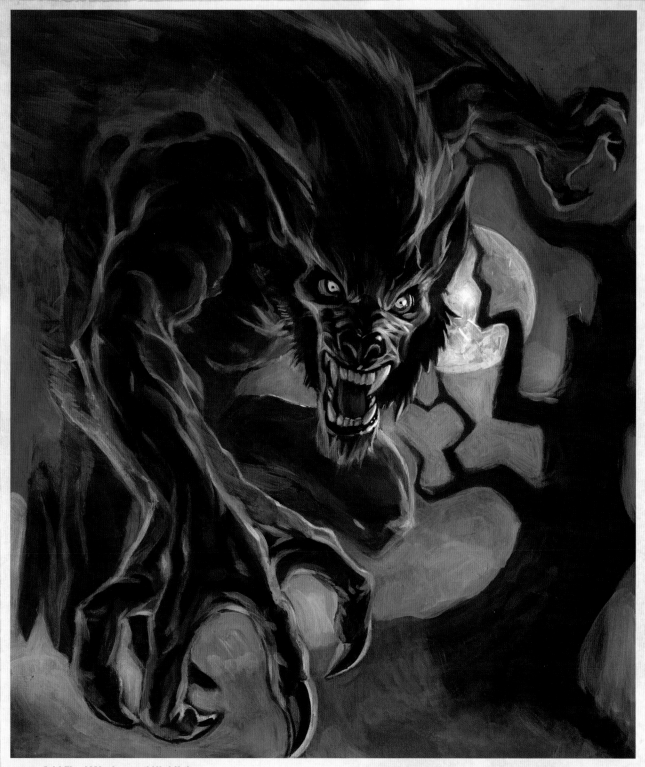

8 Add Final Washes and Highlights

Add a dark Phthalo Blue wash to cool down the background and bring out the werewolf's warm colors. Even the greens of the grass are blued out. Cool down the colors of the wolf's right side with washes of Phthalo Blue and Payne's Gray mixed with Titanium Buff. The only warm areas on the wolf's right side are in the mouth and around the eye.

Add highlights in the areas affected by the moon's light, and in areas of focus such as the nose, cheeks, hands and the edge of the face, with bold Titanium White. The highlights will focus the viewer's eye near the face and forward hand.

WEREBAT

THIS IS A TRUE MONSTER. HE'S A BIG NASTY CREATURE, HALF man, half bat, half demon. Is that too many halves? He lives in caves and searches for prey among the hikers who climb the mountain trails.

More a beast than man, he tears his prey apart to drink their blood and eat their entrails.

Mmm…entrails.

1 Capture the Personality Through Movements in a Gesture Sketch

The bat hangs in the sky, its wings reaching out to propel it through the air. The main focus of this piece is the movement of the wings and the arms. The back of the werebat arches up from the back of the head, around to the base of the spine. The flow follows through to his back leg, turns at the knee and goes back down to the foot. The arc of each wing comes out of the back, arches up, hits the elbowlike joint at the middle of the wing, goes up to the handlike spread of the wing, then out and down the arc of the fingerlike appendages out to the ends of the wing.

2 Construct the Figure

Draw circles for the basic joints, including the knees, elbows, shoulders and where the wings exit the back and where they bend. The bat wing is like an arm and a hand with very long webbed fingers, so treat it like you would a regular hand. Remember to add detail circles for fingers. Add the shapes of the eyes, nose and ears.

3 Refine the Pencil Drawing

Add the details. Erase the structure of the drawing and render on top, adding textures such as hair. Keeping your lines simple, connect the circles, fleshing out the arms, legs and wings with simple tubes. As you begin to render the creature, use thicker lines and erase the structure lines.

Composition

The wings bring you from the top of the piece down into the head area. The composition then flows down into the moon, which surrounds the bat's head and upper torso.

4 Finish the Pencil Drawing

Add details now. Render the shadows and darken the legs. The shadows are mostly on the underside. Notice the difference between the wings in the two images here. After the initial drawing, I decided to check out some wing reference material and made the wings much more batlike. Bat wings are actually arms, with flaps of skin stretched from the side of the body, out between the fingers on the hands. Check out the more handlike structure in the finished drawing.

Scan and Tint the Drawing

Scan the drawing. Duplicate the Background layer. Name the new layer "Drawing" and set it to Multiply. Use the Photo Filter to tint the drawing reddish brown.

If you'd rather paint, transfer the drawing to thicker paper with a reddish brown colored pencil.

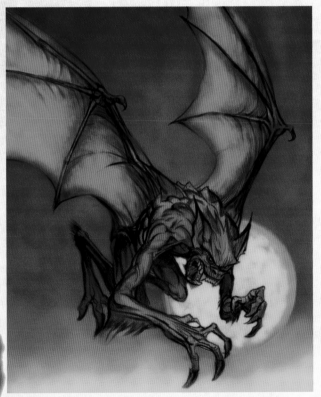

5 Add the Color Wash and Begin Base Colors

Create a new layer and name it "Base Tone." Use the Paint Bucket to fill it with a medium red tone. Use the Airbrush at a medium opacity to apply yellow and orange to the moon, fading the colors out to the deep red at the top of the composition. Layer one color over another.

Airbrush some lighter red-oranges at the bottom of the piece, layering low-opacity color over and over to build up rich colors. Next, use the Airbrush at low opacity to add a faint pale yellow at the bottom for a smoky, soft image. Make sure the Drawing layer is on top of this layer and that it is set to Multiply.

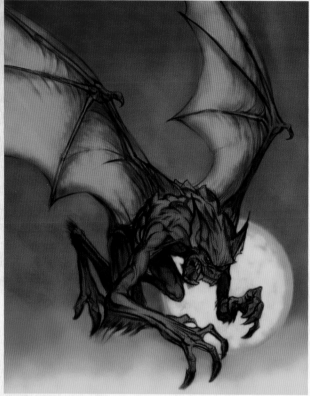

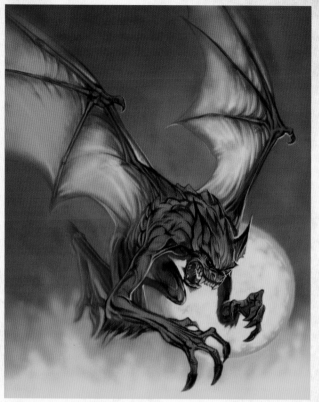

6 Establish the Midtones

Create a new layer named "Color" with Normal mode at 100%. Position this layer under the Drawing layer. Select the shape of the creature with the Lasso tool (while holding down the Option key [PC: Alt] for accuracy). Fill this with a reddish gray. Against the red and yellow of the background, it will look blackish gray. Keep the color under the wings and ears lighter orange to make the wings look translucent. Add green to the eyes for complementary color contrast.

7 Establish the Darks and Edges

On the Base Tone layer, add cool dark color to the shadows on the body. These shadows will appear under the Drawing layer and add more depth.

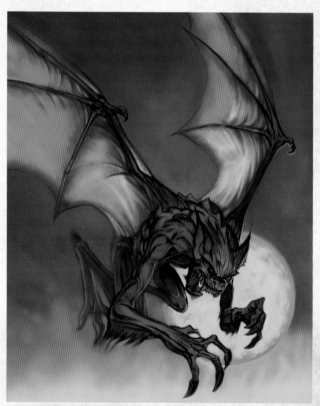

8 Establish Light Opaque Tones

Use the Airbrush to add opaque colors on the Drawing layer. Add purplish reds to the left hand side of the creature. As you add reflective light, make sure it's always on the same side of the forms and muscles. Add yellows to the sky, wings and edges of the creature facing the moon. Add opaque rim lights on the werebat. Airbrush some pinkish purple in the background and some cooler reds on the shadows to create a sense of atmospheric perspective.

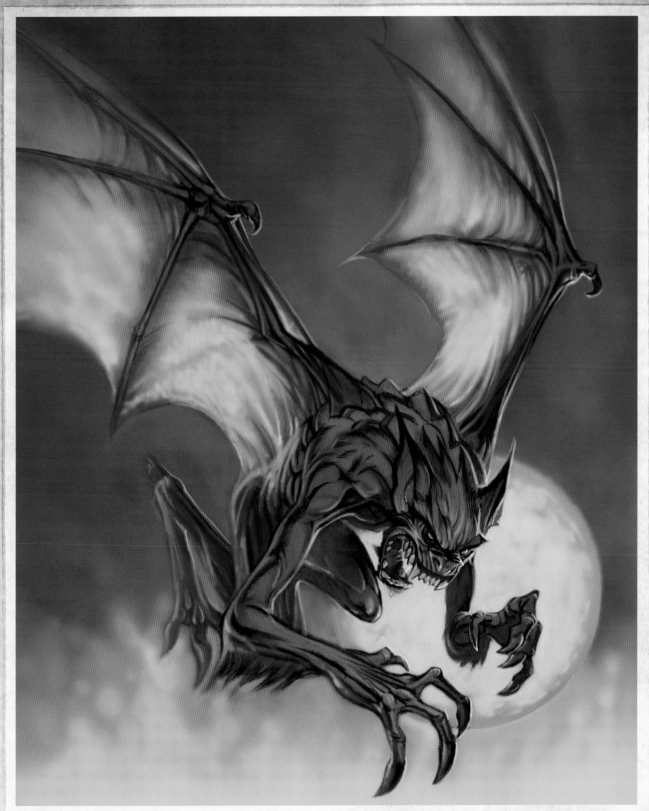

9 Add Highlights

Fade the legs into the background by lightly airbrushing the background colors over the legs. Using the Airbrush, drop reds into the shadows, using a more purplish red, with the warm yellows coming from the moon. Add green to the eyes and reinforce some of the highlights and shadows. You're done!

SWAMP CREATURE

IT LURCHES OUT OF THE BLACK WATERS OF THE DEEP SWAMP.
The hideous monster slithers into the depths of the night. Slime and detritus hang from its scaly skin. It looks like an unholy combination of ancient alligator, decrepit catfish and the old man of the swamp. Its spiny piranha-like teeth protrude forward out of its hungry jaws, threatening to sink into your meaty flesh. Its burning yellow eyes scan the lagoons for helpless victims to drag back to its lair.

STUFF YOU NEED

DRAWING SUPPLIES
pencils, eraser, drawing paper, photocopy paper for sketches

OTHER SUPPLIES
scanner, computer, photo-editing software

1 Capture the Personality Through Movements in a Gesture Sketch

Create the sense that this thing is dragging itself out of the swamp, ready to eat babies and old ladies. It half walks, half slithers out of the fetid waters. It's hunched over, water dripping off its back. Its hands extend outward, reaching for the viewer, its next victim. Start with the head, then arc the line for the spine around and down into the water. The weight of the creature is forward, its hips carrying the weight evenly on its two legs. Bend the legs forward at the knees.

2 Construct the Figure

Add the arms and legs. Account for the fingers, giving the creature nice vicious-looking hands. Build up the basic shapes of the rib cage, hips and legs. Draw circles for the knees, elbows, hands and feet. Remember to draw the circles for all the joints, including the knuckles. Add the pointy spikes coming from his back and around his face.

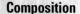

Composition
The arcing shape of the creature dominates the composition. The head and the hands of the monster create a triangle.

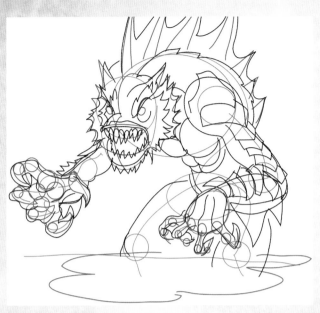

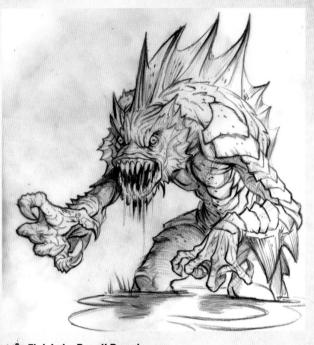

3 Refine the Pencil Drawing

Connect the dots between the lines and shapes you've created. Allow the circles to flow into arms and legs. Use your knowledge of anatomy to guide your drawing.

"Costuming" the Creature

While the creature doesn't wear an outfit per se, the scales and textures of its skin are much more interesting than just a naked body. Think of fish scales, alligator's skin and other monstery textures to make him truly gruesome. Build these elements with basic shapes and texturize them using your handy pencil.

4 Finish the Pencil Drawing

Solidly define the edges of your drawing. Get into the darks and tones. Keep in mind the light source, which is coming through the trees from the upper right. Draw the shadows in areas away from the light. The head and back are shading most of the front of the figure, so keep this area mostly in shadow.

Draw the surface of the water. It's a reflective liquid surface, but the creature is also casting its shadow upon the water.

5 Scan the Drawing, Wash in Color and Establish the Background

Scan the drawing. Duplicate the Background layer. Name the new layer "Drawing" and set its mode to Multiply. Use the Photo Filter on the Drawing layer.

Paste in a greenish-yellow texture layer (see "Build a Digital Texture Library," page 42) and position it under the Drawing layer.

The background has a subtle tree/swamp effect, so use the Chalk Brush set at medium opacity to scumble in some yellows to create the illusion of light coming through the trees. (Scumbling means roughly layering colors so that hints of the lower color layers show through.) Little dashes of green and yellow create the effect of grass poking through the water. Keep it abstract, just making shapes. This will give the impression that you did a lot more work than you actually did.

6 Establish Darks and Edges

Select and color-adjust the darker areas of the piece (Image menu : Adjustments : Hue/Saturation and Image menu : Adjustments : Color Balance).

Block in the shadow shapes (expanding on the shadows you created in the pencil drawing) using cool greenish brown and warm dark brown. Add deep dark red, pale turquoise and bright cool blue into the shadows. Avoid mixing them in with the browns; lay them on top. Add some red to the lips and eyes for nice color contrast.

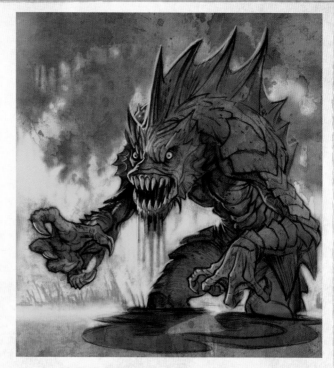

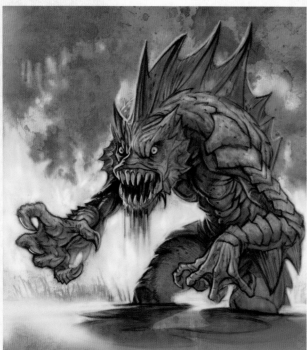

7 Establish Light Opaque Tones and Midtones

Using cool pale yellow, paint the light areas on the figure. Create a rim light and add highlights and light tones to the areas of the figure that are hit by the light from the background. Use the Brush to softly scumble the yellow into the plates on the monster's back.

Place some turquoise firmly in the shadows to represent reflected light from the water. It will also help define and render the creature. Let this undercolor softly blend into the shadows. The yellow of the main background light will have a sharper, higher-contrast edge.

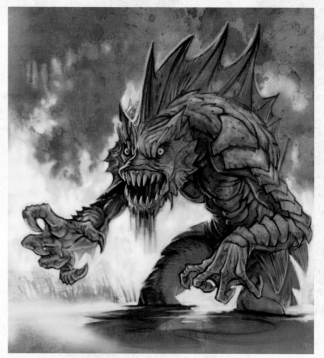

8 Add Highlights

Add white highlights to the light areas. Place the highlights right next to the darks for a wetter, glossier effect. High contrast creates the illusion of shine.

Dab more turquoise into the shadows and the water. This will create a blue-green reflected light from the water and will give the piece a more 3-D feel.

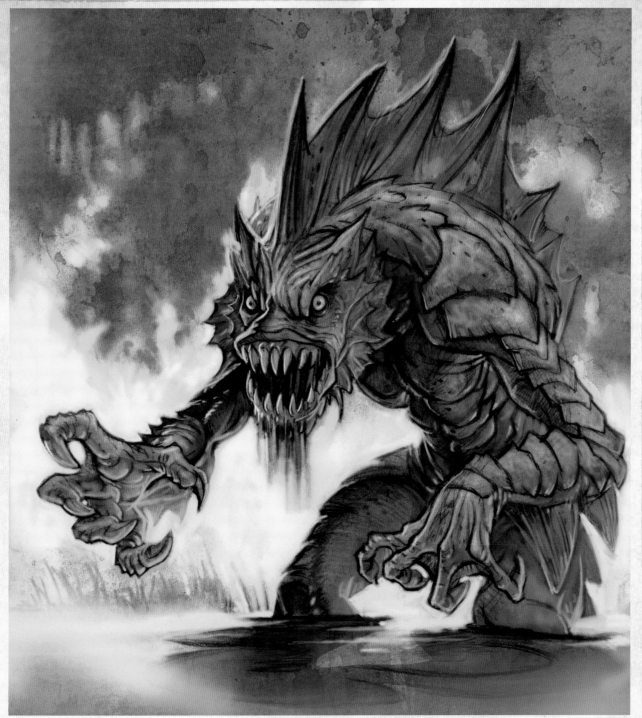

9 Cut in the Background

Bring the yellow-whites of the background up to the edge of the figure, almost "cutting" a sharp edge against the creature. This will add definition to the monster. Look at the differences in these hand images to see the progression of the edge between the hand and the background.

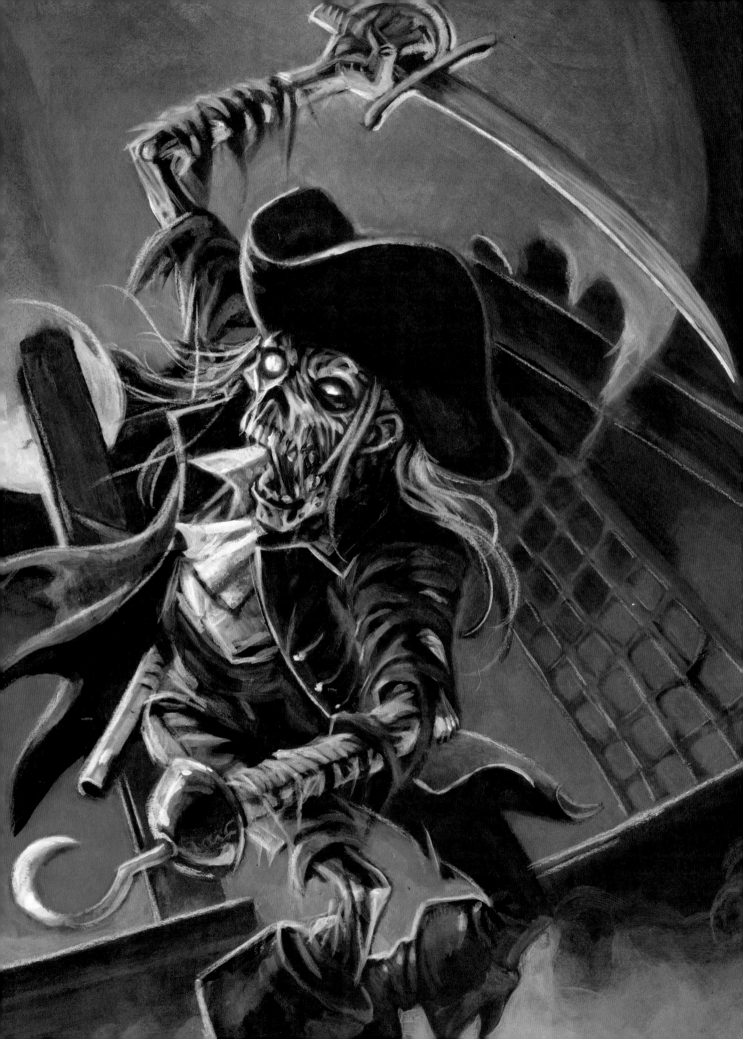

THE UNDEAD

ZOMBIES, MUMMIES, THE HEADLESS HORSEMAN, AUNT IDA'S FRUITCAKE … SOME THINGS NEVER DIE, or rather they die, but they come back to haunt you. These horrifying monsters remind us that instead of heaven and hell, there might be a far worse fate after death. Zombies have lost all of their humanity, and the only thing on their minds is their next meal: your brains. The others restlessly haunt our nights, seeking something to complete the puzzle of their lives, only to search vainly and eternally.

I dare you to open the crypt to find inspiration where others find only terror.

ZOMBIE

IT LUMBERS TOWARD YOU, SHAMBLING DOWN THE STREET, slowly but unwavering. It's not your little brother; it's a friendly neighborhood zombie, Jimmy Boombatzi the high school football star.

Whether he was returned to life through a profane act of a voodoo priest, a bizarre aftereffect of a strange asteroid entering the Earth's atmosphere, or some contagious zombie disease, is irrelevant. Jimmy is back for one thing—to eat your brain! Here we catch him just as he's escaping the grave. This creature is a lot of fun to draw. Just remember to make things as gross as possible.

STUFF YOU NEED

DRAWING SUPPLIES
pencils, eraser, drawing paper, photocopy paper for sketches

OTHER SUPPLIES
scanner, computer, photo-editing software

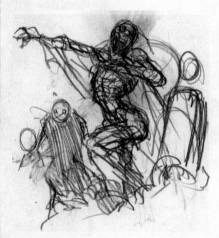

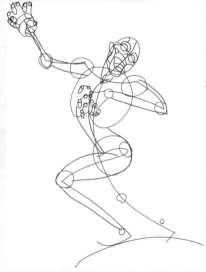

Composition

One hand is outstretched, unbalancing the mass created by the ground, gravestone and body. Use the moon as an object that keeps the eye moving around the piece. The circle is a strong compositional element because it draws the eye and calls special attention to any object that breaks its edge.

Each key element is balanced by another. The gravestone in the foreground balances the outstretched arm. The figure in the background balances the large area of sky on the other side. The forward arm balances the elbow thrust of the back arm. Bend the front knee to balance the arm in the back, creating the impression of forward movement.

1 Capture the Personality Through Movements in a Gesture Sketch

His arm is reaching forward. He's been cooped up in a little box underground for a while and feels the need to stretch. His gesture should feel unbalanced, as if he could fall over at any moment but doesn't. Tilt his head back so it looks like it might fall off as he turns to look at you. His gesture (and your pencil marks) should be jagged, quirky and uncomfortable. The main action runs from his back foot up to his outstretched hand.

2 Construct the Figure

Flesh out the figure, building off of the three major body shapes: the rib cage, hips and head. Draw the figure bending backward at the hips and shoulders, with the chest pushed forward. The neck follows the general movement of the body and hangs backwards off the torso. After these elements are in place, draw the limbs. Place the elbows, wrists/hands, knees and ankles/feet.

Exaggerate normally soft areas of the body: make knees knobby, elbows pointy, knuckles bulge, and the lips pulled back in a rigor-mortis grin. Pay attention to how the folds of the clothing wrap around the figure and help to reinforce the volumes of the arms and legs.

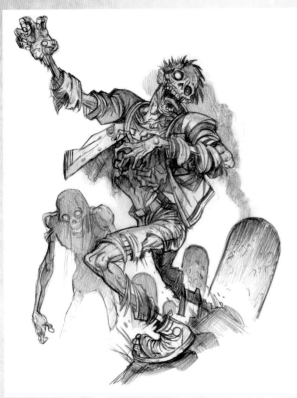

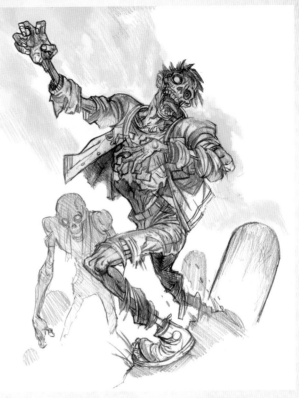

3 Refine the Pencil Drawing

Loosely scribble in the flesh on the arms and legs. Think about the costume wrapping around the body. Because this is a moving figure, show the ripped cloth blowing back, as if caught by a wind. The hair should follow the same movement.

Pick out areas of deep shadow and place the shadows near the light areas of impact. The contrast will bring the important elements forward. Our eyes tend to see shaded areas as under or behind, so treat things like the back leg with shadow to place it behind the front leg.

Use a strong underlighting. If you need a little help thinking of underlighting, get a friend to stand in front of you with a flashlight under his chin. The whole piece should feel like it's lit from some eerie underground cavern. Reflected light will be on the top of the figure as opposed to underneath. (You're essentially switching the two lighting conventions we normally use.)

4 Finish the Pencil Drawing

As you finish the drawing, think about textures. Bring the main figure forward by using pencil lines that are darker and more definite than the ones in the background. Add details like the tongue coming out of the mouth, drips of blood and saliva, and torn cloth. Add textures to gravestones and use different rendering lines for different materials. Clean up your lines, going back and forth between pencil and eraser. Sharpen edges and lines. Use the side of the pencil to create tones. Add little highlights for glistening spittle. The higher the contrast, the more wet or shiny things look.

Tighten up the lines, but keep some sketchy edges to retain the feeling of movement. Use your line work to tell the story. Lines in a moving composition will be more shaky than lines in a static one.

Scan and Tint the Drawing

This is going to be a digital piece, so we won't ink the drawing. Instead, scan the drawing and use the Photo Filter to tint it brownish green (to create a general icky feel). Duplicate the Background layer, name the new layer "Drawing," and set it to Multiply.

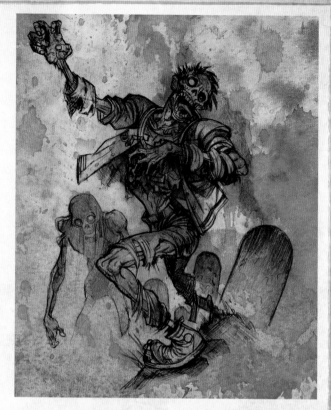

5 Add a Color Wash

Paste in a watercolor texture (see "Build a Digital Texture Library," page 42) and name this new layer "Texture." Tint it green with Hue/Saturation adjustment or Photo Filter. Move the Drawing layer above the Texture layer, then use Hue/Saturation again to lighten the Texture layer.

6 Add Midtones

Select the jacket, legs, shirt, pants and shoes using the Magic Wand, then change the areas using the color-adjustment tools. Use reds in areas like the zombie's clothes so he stands out against the predominantly green background. Choose an extremely warm red for the eyes; they'll glow when we're done.

7 Establish Darks

Create a new layer on top of the Drawing layer. Using the Paint Bucket, fill the image with a dark blue-black. Set the opacity of the new layer to 72% and change its mode to Multiply.

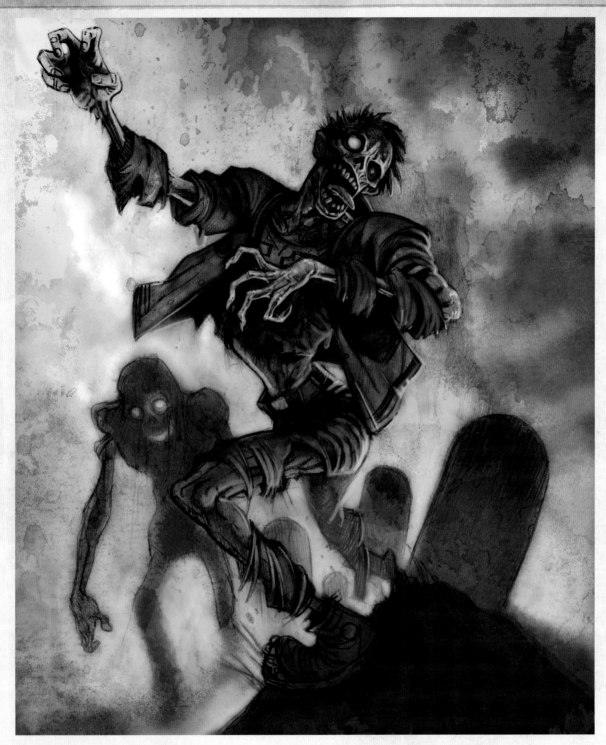

8 Establish Light Tones and Highlights

Now here's a new trick. We're going to do subtractive artwork. Select the Eraser tool and begin to erase the dark blue layer you added in step 7. Use varying opacities to erase more or less of the blue. As you work, you'll see more of the zombie peeking through. Erase clouds from the background, and midtones from the figure. Erase more from the right side of the figure than the left. The more you erase, the more bright color from the lower layers will show through. Erase the eyes completely so that the yellow and red shine brightly.

Add highlights to the face and arms of the figure from a light source coming from the right. Most of the lights will be on the foreground hand and the head.

The color is the real fun here. The reds and purples in the figure create a nice color contrast between background and foreground. By erasing the darks, we were able to create a more mottled skin, which adds to the feel of rot. This piece is a blast!

ZOMBIE PIRATE

HE WAS EVIL AS A LIVING MAN, AND NOW HE'S TWICE AS BAD as a zombie. Once he craved gold; now he craves human flesh. This rotting scavenger of the seas is on the attack, rearing back with his rusty old saber, threatening to chop off your head and eat your brains. Unlike the average zombie, this pirate zombie is more agile and dangerous. He's moving fast and coming at you. When you discover the sunken wreckage of a ship that sailed under the Jolly Roger, beware!

STUFF YOU NEED

ACRYLIC PIGMENTS
Cadmium Red Medium, Cadmium Yellow Medium, Payne's Gray, Phthalo Blue, Titanium White, Van Dyke Brown

DRAWING SUPPLIES
pencils, black colored pencil, white colored pencil, drawing paper, photocopy paper for sketches

OTHER SUPPLIES
spray sealant, jars for mixing, reference photos of seventeenth-century clothing

Composition

The red S curve keeps the eye zigzagging across the page. It's the most powerful movement in the piece, followed by the orange C curve formed by the rest of the zombie's body. Behind the zombie, the floor, ship and sail cut across at varying angles. The main sail and the ropes stick up at odd angles. All of these lines create a busy, moving background, but their subtle colors push the main figure forward.

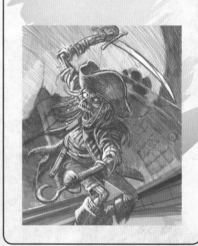

1 Capture the Personality Through Movements in a Gesture Sketch

The head, spine and weight-bearing leg make a large C shape. We'll counter that with an overlaid S shape, which starts at the tip of the sword and swoops around to the end of the hook.

2 Construct the Figure

Place a circle for the head and another for the torso tilting back. Draw a center line on the torso circle. Draw circles for the elbows and hands. Draw the hook hand large, as if it's coming at you. Objects in the foreground will be larger than distant objects. Objects that recede into the distance will start large in the foreground and become gradually smaller.

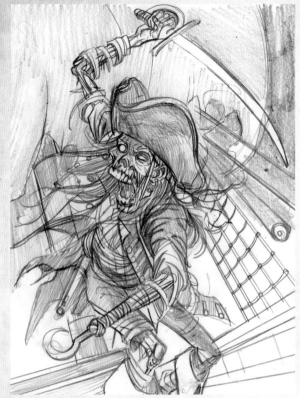

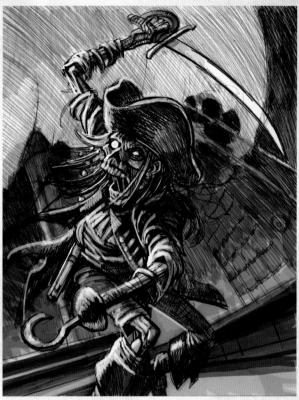

3 Refine the Pencil Drawing

Add the hat, cravat, coat, sword, hook and other details to the figure. Reference seventeenth-century clothing styles. The clothing drapes off the body, hanging down and slightly back, creating a drag from the figure. This accentuates the forward movement. Darken lines where the shadows will fall, keeping textures in mind. Draw all kinds of bumps and marks on the skin to make the zombie look truly gross and scary.

4 Finish the Pencil Drawing

Go crazy with the tonal rendering. Lightly shade everything with the side of your pencil, except areas meant to be completely white. If you need to, pull out the light areas with an eraser. Then build darks with your pencils, darker and darker until you have a rich tonal scale throughout the piece. If you have to darken areas to black, use a black colored pencil.

5 Apply a Tonal Wash and Add Highlights

Cover the image with a blue wash, using a mix of Phthalo Blue and Payne's Gray. This will establish most of the middle to dark colors. Adding the highlights now will make it easier to tone them back later. If the wash overtook the whites, go ahead and reestablish them (his eyes, the moon, the glint on his hook, anything being hit with the light of the moon).

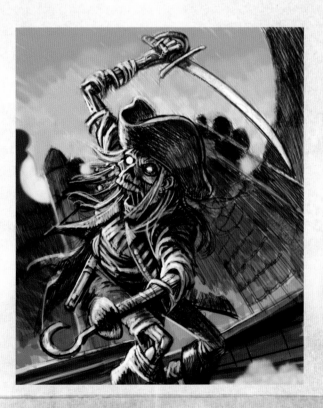

6 Establish Midtones and Add Warms

Add some Van Dyke Brown to your blue mix. Add some of this color to the sail and other parts of the boat, but mostly reserve if for the figure. The brown colors are warm against the cools in the background. Don't be afraid if the image gets too dark; we'll bring out the lights again.

Because the tonal rendering was so detailed and the entire piece was covered in a wash, it's already pretty dark, so we're going to skip ahead to adding lighter tones.

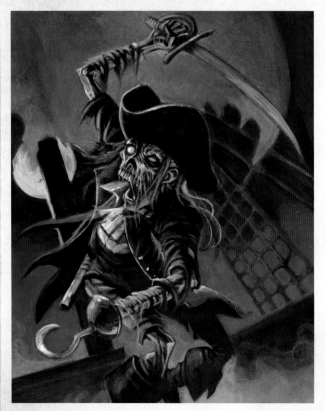

7 Establish Lighter Opaque Colors

Mix Cadmium Yellow Medium with Phthalo Blue to create green. Now paint into the darks in the foreground. Imagine that there's a warm fire on the deck of the ship that's glowing up onto the front of the zombie. Paint the greens on the skin of the arms and head. Put warm light browns and yellows into the clothing, and in reflections of the metal and other places. Paint pure yellow in the eyes so they glow nice and bright. Add more yellows to the green.

Start defining objects such as the boat mass and sail with more light or white edges as if they are rim-lit by the moon. Paint the white shirt with Titanium White mixed with a tiny bit of Van Dyke Brown or Payne's Gray, depending on whether the object you are painting is in the moonlight or the fire glow. Add some oranges to metal objects such as the hook and the sword.

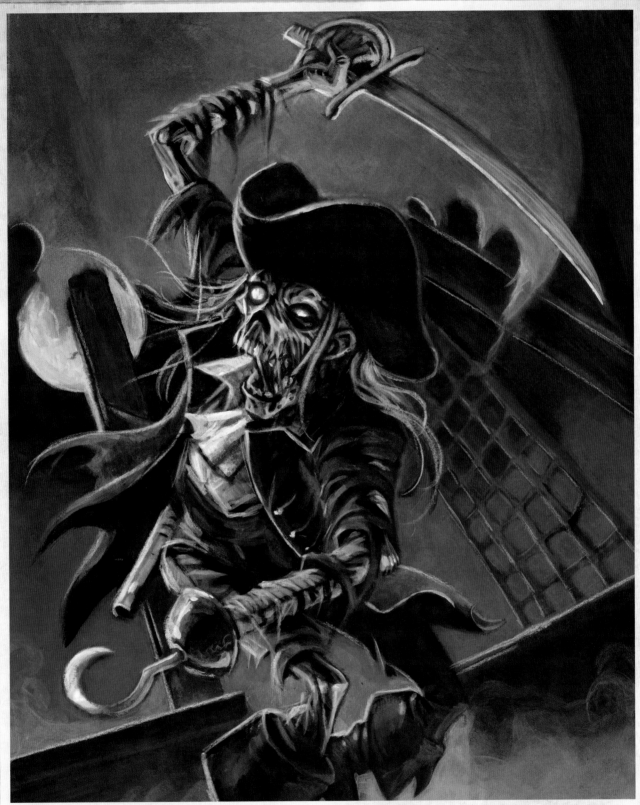

8 Add Final Highlights and Details and Evaluate the Final Piece

Add the final bright yellows to the skin on the face, hands and arms. Pull out the extreme warm highlights. Use a white colored pencil to draw in the thin, scraggly hair. Add some warm browns to the coat folds and maybe a dash of Cadmium Red Medium to the edges of the eyes. This will make the skin and the yellow of the eyes really pop. Now you have a finished, scary zombie pirate! Arrgh!

MUMMY

THE MUMMY'S CURSE DRAWS HIM OUT OF THE TOMB TO terrorize the night, killing those who helped to disturb his final rest. He is a creepy, stiff, ragged creature moaning and lurching toward the viewer.

1 Capture the Personality Through Movements in a Gesture Sketch

This mummy just woke from a five-thousand-year sleep. I would expect a bit of stiffness from lack of movement to be reflected in his gestures. His back is straight and stiff, his head is tilted at an odd, uncomfortable angle, his arms—which, up until now, were crossed over his chest for eternity—are beginning to reach out as rigor mortis unwinds itself. The hands are a major focus in the gesture. The fingers need to look like they are feeling the air for the first time in millennia and are beginning to reach out for your throat.

2 Construct the Figure

Building on the gesture, fill out the head, arms, fingers and hands of the mummy. The sarcophagus won't need too much construction, but you might want to add the facial structure and line patterns. Use reference photos; having something real to draw from makes your drawing more believable. I did this piece on two separate pieces of paper—the mummy on one and the background on the other—so that I could render the background completely without interfering with the main figure of the mummy.

Composition

We're going for calm composition based on a simple X shape. The sarcophagus in the background begins a line from the upper left of the page, down to the hand on the right of the page, following right down the arm. Crossing this is a less complete line (but one that is definitely there) from the lower left of the page, up the arm to the wraps on the chest, then to the face and up and out of the paper. This X-shaped composition brings the focus of the piece squarely to the center.

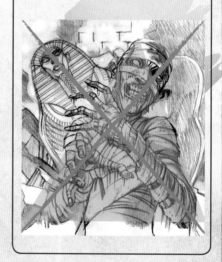

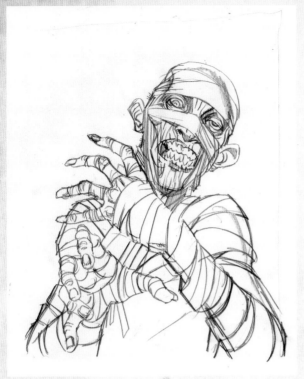

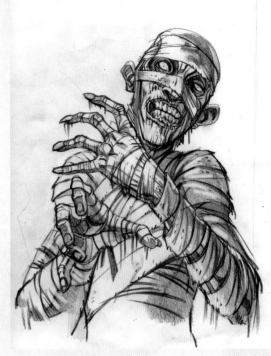

3 Refine the Pencil Drawing

Fill out the figure of the mummy as you have with other pieces. Don't worry too much about muscles; the mummy has been atrophying for millennia. Work out the major masses of the body—shoulders, arms and head—and focus on the construction of the hands and fingers. Look at your own hands in the mirror, making all kinds of different motions with them and drawing what you see.

The mummy should have a ragged texture; use your pencil in short aggressive movements to mimic the texture of the cloth. Allow the clothing to wrap around the figure and hang in places as if it has been aging and is falling off his body.

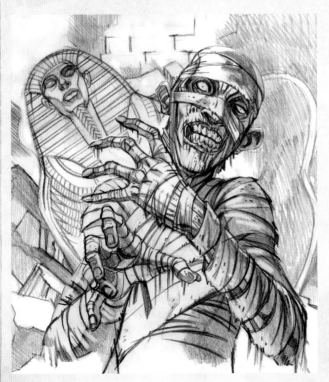

4 Finish the Pencil Drawing

Establish the important lines on the figure and begin to form the wraps. Draw the wraps as ellipses rather than as straight lines over the arms and body. You want the wraps to follow the forms of the figure.

Try different texture-drawing techniques and create a lot of different textures for this piece—rotted skin, ancient wraps of cloth, stone and the shiny material of the sarcophagus—each should have its own texture.

Allow the skin to have dark rivers of shadow running through it where the skin has dried out and created odd folds or ripped open. Pull the lips away from the gums in a sardonic rigor-mortis grin, exposing the teeth. Sink the eyes into the head by creating dark circles where the sockets bulge through the skin surface.

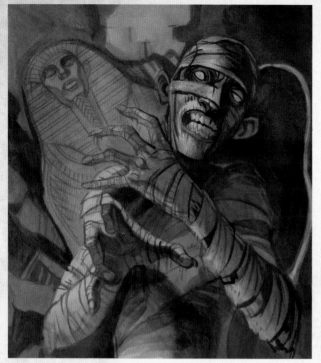

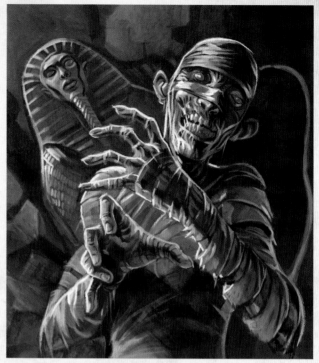

5 Add a Color Wash and Establish Midtones and Darks

At this point, I take the piece that is now on the computer and print it out onto a heavy-weight paper, then tint it with a Raw Sienna wash. I use the Strathmore 500 Series 3-ply Bristol in my Epson 2200 printer. If you don't have access to a nice printer like this, an easy way to mimic this is to start the initial drawing in pencil on the Strathmore paper, but finish it in black pencil and then tint the whole piece with a Raw Sienna wash. Essentially this will produce the same effect. All of the midtones are pretty much set up now.

You will have to reinforce the darks with Burnt Umber or Van Dyke Brown in the shadows, and begin to color in the opaque light tones. At this point, since you want a lot of the Raw Sienna effect here, don't overpaint the color too much.

6 Establish Lighter Opaque Tones and Highlights

Start adding flesh tones and lighter Raw Sienna tones to the light areas of the figure.

The skin tones of the mummy are tints of Cadmium Red and Titanium Buff lightly painted over the underpainting. The teeth have more Yellow Ochre and Raw Umber mixed in. Raw Umber has a lot of green in it, so mix it with other colors to unify the piece.

For the wraps, I used a lot of Titanium Buff, Titanium White, Raw Sienna and Burnt Umber. The wraps' shadows are Raw Umber and Ultramarine Blue Light mixed together, which creates a cool bluish gray that helps to round out the lighting. The more blue and less Raw Umber, the farther the wraps recede from the main light source. Remember to allow the warm tones to meet up next to the darkest tones. This will contrast nicely against the dark brown umber colors of the background and create a nice atmosphere.

Lastly, create a nice color/tonal contrast in the eyes by hitting the red of the eyes with a white dash of paint. Voilà!

Color Breakdown

Most of the colors in this piece are warms, a nice contrast to so many of the other pieces in this book. Even the white areas of the wraps are warm. I contrast this with a cool Ultramarine Blue reflected light on the right side of the piece. This gives the piece some color vibration and adds to the 3-D illusion that the objects in the piece are existing in a space with other objects reflecting light from different directions.

7 Add Final Details

This image is a subtle piece with the midtones of the Yellow Ochre and Raw Sienna dominating. The mummy emerges out of the dimly lit room. All the colors are fairly muted except for those around the face. There are dashes of other colors throughout the piece, but these are just hinted at and painted in the same tonal range as the background of the piece. The eyes contain the only bold color in the piece, drawing you immediately to them.

HEADLESS HORSEMAN

IN SEARCH OF A NEW HEAD, THE HEADLESS HORSEMAN rides through the streets of Sleepy Hollow by night, scaring passersby and haunting poor Ichabod Crane. The mission of the piece is to show the fearsome horseman on horseback, leaping through the night. His pumpkin head is in his hand, burning and ready to be thrown at a victim, its evil grin laughing at their fear.

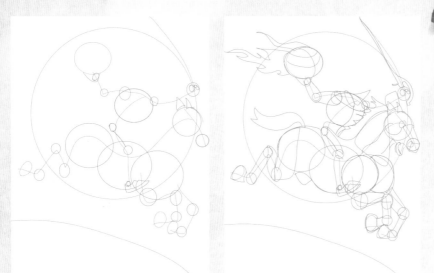

1 Capture the Personality Through Movements in a Gesture Sketch

We're drawing two creatures: the horse and its rider. Start with the curving arc of the horse's spine, stretching from the head to the hips. Hang the four legs from this structure. Remember that the hips take up the greater part of the back of the body, while the shoulders are down and in the front. Get some references photos of running horses for accurately positioning the legs.

Now create the gesture of the horseman. He's sitting on the horse, so the position of his legs doesn't affect the balance. Instead, the hips hold the weight of the figure. This allows him to really twist his body, creating a nice balance between the hips and shoulders.

Composition

Use a large circle for the moon in the middle of the piece to hold in the entire figure, allowing you to create exaggerated movement. The horse and rider break the plane of the circle, creating a bold and striking design.

2 Construct the Figures

Draw a circle for the top of the horse's head and a box for the muzzle, keeping the volume of the snout in mind. Draw big circles for the shoulders, the stomach area and the hips/rear. From the shoulder area, the front legs come off from either side; the back legs come off from either side of the hips. Horse legs have different joints than human legs, so look at your reference photos to arrange circles for ankles, hooves and knees.

The horseman is lunging forward with his sword, holding his pumpkin head back, ready for an attack. Draw the construction lines. Remember, the legs won't affect the upper-body movement.

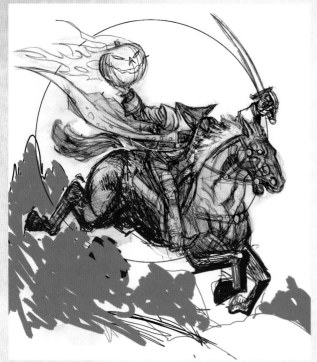

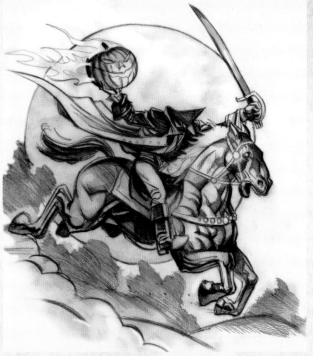

3 Refine the Pencil Drawing

When drawing the figures, keep the values in a middle range until you determine where the boldest, darkest areas should be. This will create a deep, rich shadow structure, which makes the image exciting. Keep the horse and rider mostly black, as if in silhouette, with the moon providing the light source.

4 Finish the Pencil Drawing

Draw a spooky face on the jack-o'-lantern. Make the horse's eyes wild to play up the drama. The more open the eyes, the wilder they appear. Add a background at the bottom to ground the image. Keep it simple so it doesn't interfere with the main figures. The background could be a nice countryside by night with farms in the distance.

5 Scan the Drawing and Add a Color Wash

Scan the drawing. Duplicate the Background layer, name the new layer "Drawing," and set its mode to Multiply. Create a new layer under the Drawing layer and fill it with dark blue. Now all of the colors will play against this very strong color. The dark blue will come through the lighter colors in the final piece.

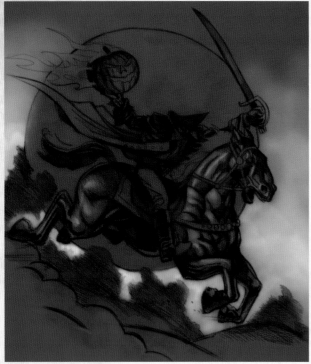

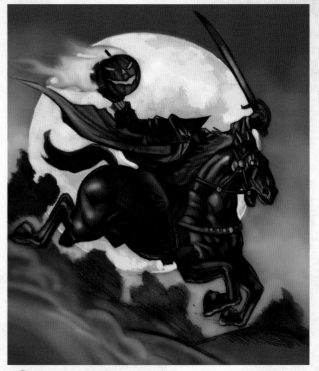

6 Separate the Forms

Apply white to the background with several applications of the Airbrush tool at a low-opacity setting. Build white in some areas while leaving the blue coming through in others. Toning back the sky will separate the background from the main figures. You can also add highlights to the figures using this method.

7 Add the Basic Colors

On the Background layer, use the Airbrush to tone the background surrounding the moon with a light turquoise. Select a circle for the moon and paste a moonlike watercolor texture into it (see "Building a Digital Texture Library," page 42). Lasso the pumpkin area and shift its color to orange using the Color Balance adjustment. In the same manner, add colors for the ground, horseman, jacket and horse. With the Airbrush, add some low-opacity browns to the horseman's outfit. Base in the fire area by selecting it and using the Color Balance adjustment to make the area yellow. Over that base fire color, airbrush oranges and yellows to complete the fire.

At this point I decided that the turquoise background is too intense and interferes with the figure. In the next step I'll change this to make the background recede more.

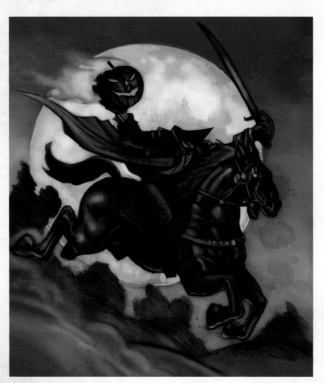

8 Refine the Colors

Paste in a blue, watercolor-texture layer and put it between the bottom layer of color and the Drawing layer to deepen the blues. This tones back the turquoise and the other colors in the piece. You can see how the watercolor texture comes through the colors now.

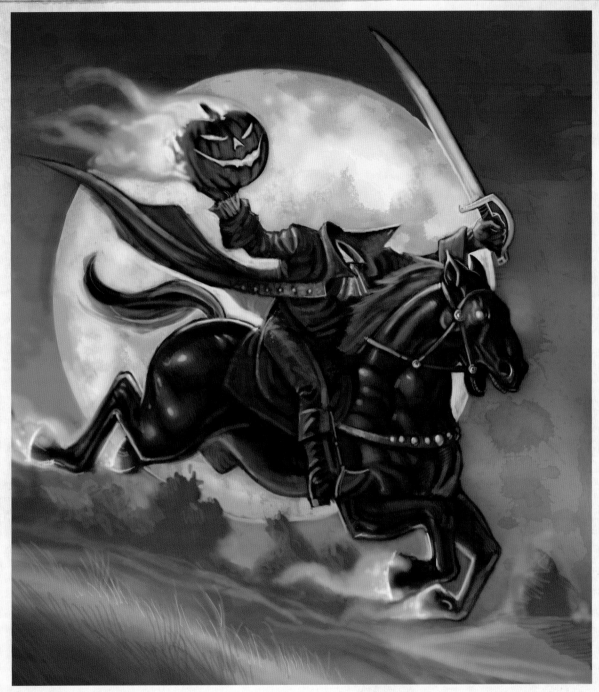

9 Add Highlights and Textures

Use the Airbrush to put in the strong colors on the topmost layer. Add more oranges and yellows to the fire on the pumpkin and to the horse's eyes and feet. Using the pumpkin as a light source, place highlights on the coat collar and sleeves, and on the horse's neck and body. Using the fire on the hooves, create orange and red reflected lights on the underside and legs of the horse and horseman. Restrict the cool whites to the upper side of the horseman and the warm yellows, greens and reds to the underside. Use the Airbrush to create a fog under the horseman to separate him from the background.

Use the Chalk Brush to add browns and textures to the coat and pants. Add browns only within the light range from the pumpkin. Use warm colors on the side of the horse facing the pumpkin and the fiery legs. Add reflected turquoise to the sides of the horse away from the fiery pumpkin and feet. For the ground, add pale yellow-greens with the Airbrush. Keep it loose at first, then make the brush very small and start drawing in the grass. Use the Airbrush to lay in more blue-green fog in the background. Allow the moon to reflect in the sword and on the horse's tail and mane by using colors selected from the moon in the highlights.

Tone back the Background layer by darkening the color and lowering the saturation so that it doesn't interfere with the horseman. The horseman should be iconic and leap off the page.

GHOST

IT HAUNTS OLD DARK HOUSES, CLOSETS IN THE NIGHT; IT comes out of the darkness to terrify unsuspecting victims to death. Nothing can stop the ghost as it passes through walls as if they didn't exist. Its moans and howls are heard throughout the night as it creeps up behind you.

Wrapped around it are the chains of past sins, binding the ghost to this mortal plane.

STUFF YOU NEED

ACRYLIC PIGMENTS
Cadmium Red Medium, Cobalt Turquois, Payne's Gray, Titanium White

DRAWING SUPPLIES
pencils, eraser, black drawing ink, brown drawing ink, drawing paper, photocopy paper for sketches

OTHER SUPPLIES
scanner, computer, photo-editing software, spray sealant, jars for mixing

1 Capture the Personality Through Movements in a Gesture Sketch
Start with a thumbnail sketch to get the basic idea down. The ghost is reaching out to grab the viewer with its cold, ghastly dead hands. Include the clothing in this gesture. Draw an arc from one hand to the other and from the head down to the ethereal nothingness at the bottom of the ghost. Gesture in the open mouth, silently screaming, and the open holes of the dead eyes peering into hell.

Composition
Arrange the ghost at the top right of the page, as if it were coming out of the page to consume the wary victim.

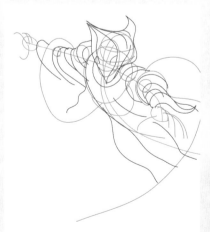

2 Construct the Figure
The face should be otherworldly, so eliminate a facial feature to make the creature more freakish. I eliminated the nose and focused on the creepy eyes and open mouth. Add detail to the rib cage to suggest the body's volume.

Wrap the cloth over the figure, creating a nice flow of material. The ghost is coming toward us with its cloak trailing behind. End the cloth with ragged, shredded edges.

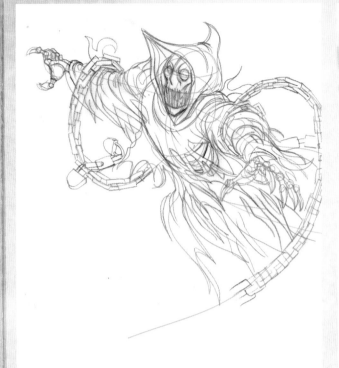

3 Refine the Pencil Drawing

Using a darker pencil, add more finished lines and erase the structural lines. You don't want to have too much detail throughout the piece; focus on the cloth, hands and face. The ghost is diaphanous, and too much detail will ground the ghost in reality. Focus on the gestural movements of the cloth, and have fun streaming ectoplasm behind the creature.

4 Finish the Pencil Drawing

Start shading the ghost. Remember that in order to make something glow brightly, the color next to the bright area should be as dark as possible. Contrast creates the glowing effect and will make your ghost seem really creepy. Now you have a truly creepy and fun pencil drawing. You could stop here, but what fun would that be?

5 Apply an Ink Wash

Apply an ink wash to firmly establish the black areas and the midtones before applying color. Loosely ink in the black areas, following the lines of your pencil drawing. Water down the brown ink and wash it into the piece, being mindful of the value range you're creating.

6 Paint

Treat the ghost as its own light source. Underlight the ghost from underneath the robes, and around the head and on the lower half of its face and hands. Keep the tops of the hands, face and head dark, while painting the lights from below. Use a mixture of Cobalt Turquois and Titanium White to add the highlights and pale areas. Add highlights to the teeth, face, hands and chains. The chains are lit by the ghost, so the light reflections should come from the ghost's direction. To intensify the glow, add some Cadmium Red Medium and Payne's Gray to the dark areas. Adding warms to the darks will make the pale blue pop more.

7 Scan, Then Make the Final Adjustments

Scan the painting so that you can add some awesome, ethereal effects digitally. Paste in a blue-gray watercolor texture (see "Building a Digital Texture Library," page 42). Set the pasted layer to Multiply to make the piece look really dark and threatening. These changes decrease the glowing quality of the painting because even the white areas had the texture coming through. To bring back the glow effect, erase the texture from the glowing areas on the lower texture layer. Leave some of the glow area to make it seem as though the ghost is coming out of the dark.

Color Breakdown

I want otherworldly and ethereal colors. The ink wash sets the piece firmly in reality with its sepia tones, so I want to break that with glowing turquoise. The blue-green of the turquoise will play against the reddish yellow tones in the browns. As I painted, I added more reds and oranges to the browns as well as red eyes. Since these colors are complements of the dominant turquoise, they add some bounce to the piece.

Why turquoise? The cold blue-green turquoise glow feels creepy and supernatural to me. Colors often evoke a visceral sensation that can guide you, especially when you're looking to create a scary piece. If a color combination feels weird to you, chances are it will feel the same way to other viewers.

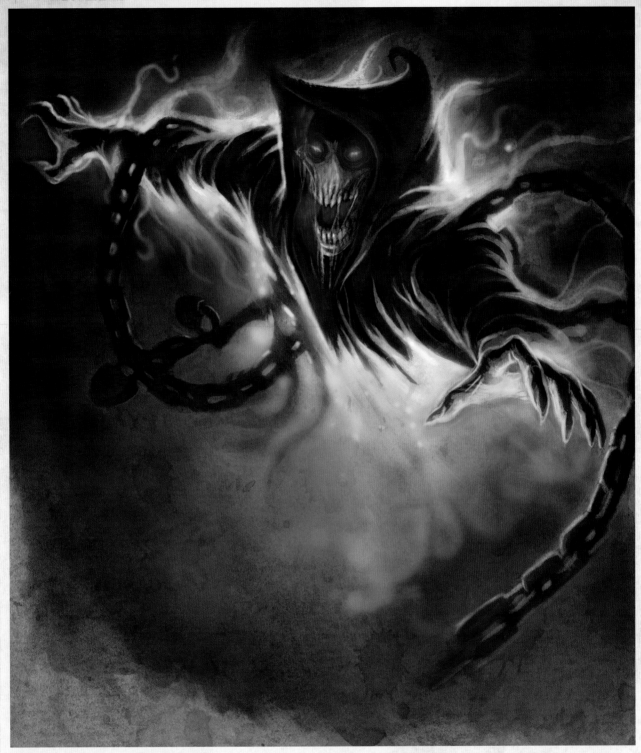

8 Finish the Eyes and Other Fun Stuff

Zoom into the face, teeth and hands and add some glistening highlights. Airbrushing pale turquoise with a tiny brush will create the effect of shiny, glistening ectoplasm, especially if you put the lights in areas that are mostly midtone to dark.

Airbrush a deep red around the eyes, in the mouth and around the head in the hood. Airbrush a light orangey red on the eyes to create the burning embers. Airbrush a bit of the same orangey red on the areas close to the head and in the mouth for a light contrast to the dark hood surrounding the ghost's head. Now it's really spooky!

GHOUL

IT COMES OUT AT DUSK, SEARCHING AMONG THE GRAVESTONES, hungry and slavering. It shambles through the graveyard, digging up old graves in search of food. Don't let it see you, though—it prefers fresh meat!

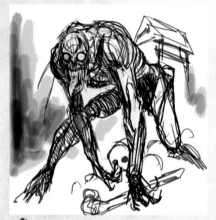
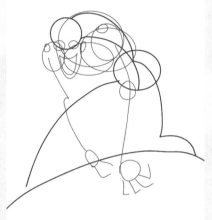

1 Capture the Personality Through Movements in a Gesture Sketch

Walk around the room dragging your knuckles on the ground and see how you move. Try to capture the feeling of lumbering and shambling in your gesture sketch. Take the gesture from the back of the head circle, over the shoulders and down over the hips, and split the weight on both legs, letting the knees take the weight, before changing direction to the feet. Draw a second gesture line for the shoulders, and create the arc running from one hand across the shoulders to the other hand.

Composition

The composition is fairly simple. The figure creates most of the composition, with the mound of dirt acting as an anchor to the bottom of the page. The mound in the background and the mausoleum are there to create a distant background, but they also reinforce the focus of the composition on the figure in the foreground.

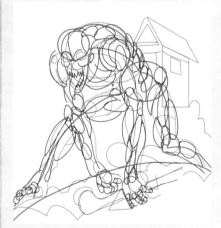

2 Construct the Figure

Develop the structure with more tubular effects to create muscles and such. After you've placed the limbs correctly, build the muscles as little, rounded bulges on the surface of the figure. It's important that you think of these shapes as bulges rather than circles, because later you will be lighting and shading them as rounded 3-D shapes.

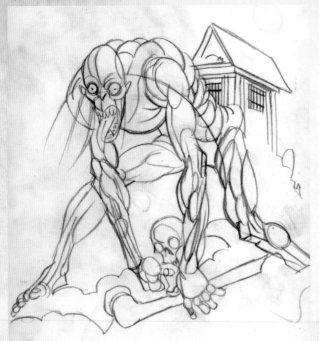

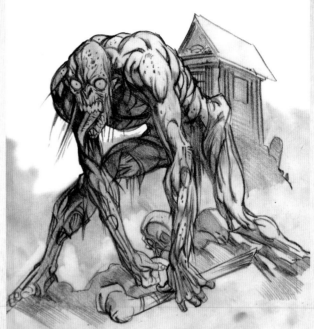

3 Refine the Pencil Drawing

Softly draw the muscles, erasing the extra lines as you form the arms, legs and head. Let the groups of muscles (rather than the individual muscle shapes) take precedence.

4 Shade, Scan and Tone the Drawing

Render the muscles as separate objects, but unify the muscle groups by shading and lighting them with a single light source. Render with the side of your pencil to get a soft transition from dark to light. The harder you hold the pencil against the paper, the darker the mark.

The shading is mostly on the undersides of the body. The light sources are coming from the top and sides, allowing the shadows to congregate underneath.

Scan the drawing. Duplicate the Background and name it "Drawing." Set the new layer's mode to Multiply, use the Photo Filter to slightly tone the pencil lines brown.

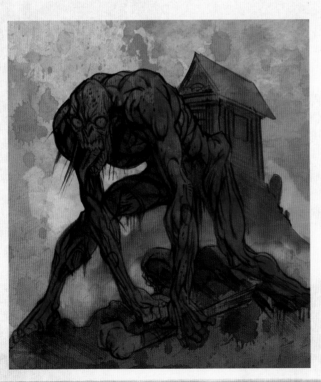

5 Add a Color Wash and Establish Midtones

Paste in a yellow wash and put this layer below the Drawing layer. Lasso the different objects, including the eyes, body, mausoleum and bones, then color them either by using the Levels adjustment or by painting with the Brush tool at varying opacities. Use a bold reddish orange for the body and purplish browns for the ground. This subtle use of complements creates a more interesting color theme.

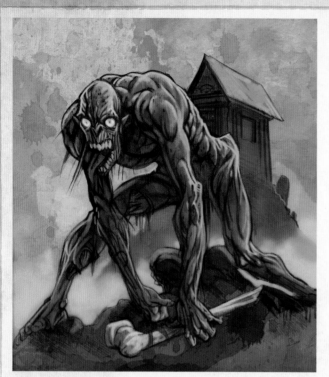

6 Establish the Lights

Start airbrushing pale yellow, orange and red flesh tones into the body. Use the lighting structure established in the drawing as a guide. The light source appears from behind and above to the right. Thus, most of the lighter tones will be on the back of the creature and in any areas that might be hit by background light.

Highlight the muscles individually with yellow. Let some of the muscle areas meld together. The masses of the arm blend together rather than bulging individually. Don't make the shadowed areas between the muscles too dark or the highlights too individual, or the ghoul will start to look like he's made of cottage cheese!

Using the Airbrush set to low opacity, add some hazy yellow fog to the background around the ghoul. This will create some distance between him and the back of the picture.

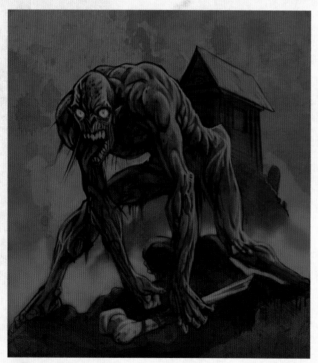

7 Establish the Darks

This step will bring the colors together, creating a unified feel for the piece. Create a new layer over the color layer, then fill the new layer with a deep purple using the Paint Bucket. Now, set the purple layer to Multiply and lower its opacity until you can clearly see the image through the color, but with a feeling of very subdued color.

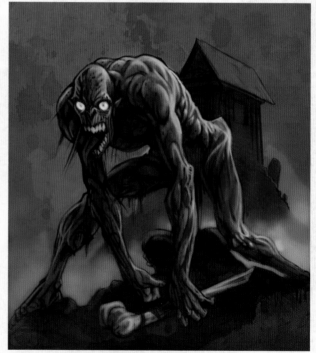

8 Establish Lighter Opaque Tones

Erase part of the purple layer using the Eraser at a variety of opacities. This develops the rendering and can create incredible depth. Using the Eraser with a soft Brush shape or an Airbrush will create very soft transitions compared to the harsh rendering that would result from adding color on top. Use the Eraser at a low opacity to pull the color out of the piece, bringing out reds and yellows again.

9 Add Highlight and Backlighting

Using the Airbrush at low opacity, brush in a strong backlight around the figure. Then, using a more opaque Airbrush, add cool blue highlights to the edges of the figure affected by the backlight. As you go, add more white to the color until you have an almost white. Place the most nearly white colors in areas of interest on the face and hands and the edge of the bone.

10 Add Final Details

Reinforce the blue backlighting with the Brush and a light blue. Erase some of the purple to add more of the yellow back into the piece. Use the Eraser with a soft Brush shape to develop the clouds in the background. You'll see just how deep the color in the piece has become.

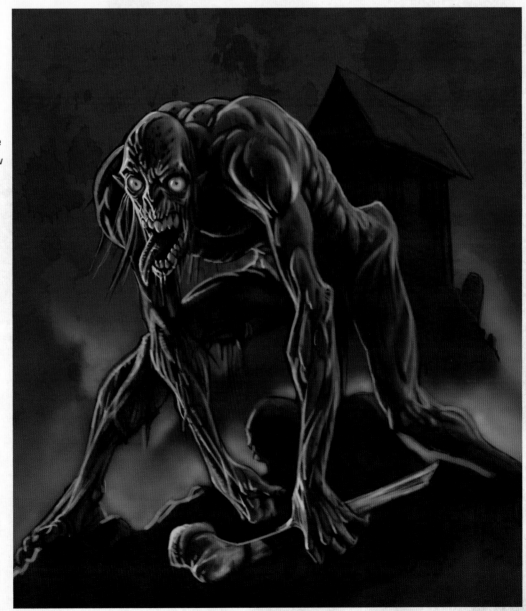

Index

A

Acrylics, 9
Adobe Photoshop, 5, 43
Anatomy, 20–27
 arms, 26
 facial features, 20, 22–24
 hands, 25
 legs, 27
 torso, 21
 See also under specific body part
Armor, 38–41
Arms, 15, 26
Atmospheric perspective, 40, 94

B

Background, 115–117
 airbrushed, 63
 distant, 78, 122
 moving, 106
 swampy, 97
 textured, 60
Balance, 102
Brush and ink, 47, 70
Brushes, 10

C

Chains, 119–121
Clothing, 42–43, 47, 81
 goth, 54–57
 patent-leather, 61
 punk, 63
 ripped, 73, 85, 103–105, 111
 seventeenth-century, 107
 Victorian, 51, 54, 70
Clouds, 40, 52, 74, 125
Color, 11–13
 adjusting, 44–45, 56
 complementary, 12, 29, 83, 90, 104, 123
 digital, mixing, 31
 ethereal, 120
 feelings about, visceral, 120
 flat, 59, 78
 intensity of, 13, 60–61, 90
 layering, 31, 36, 41
 nighttime, 52
 opacity, 30
 paint, 9
 reflected, 17
 saturation, 13
 temperature, 12, 29, 31, 78, 91
Color gradient, 81
Color harmony, 12, 36–37
Color wheel, 11
Colored pencil, 8, 107
Coloring, digital, 5, 28, 30–31

Comic-book art, 59
Composition
 anchors in, 122
 C curve, 106
 device, 46 (see also Moon, as a compositional device)
 falling, 72
 figures in, placing, 62, 76
 S curve, 106
 triangular, 38, 41–42, 69, 84, 96
 X shape, 110
 See also Eye, leading the
Contrapposto, 21, 34, 88
Contrast, 12, 17, 36, 41, 44, 49

D

Daytime, 28
Depth, 36, 41, 46, 48, 56, 87–88, 106, 124
 See also Atmospheric perspective
Detail, 18–19, 29, 119
Digital coloring, 5, 28, 30–31
Dracula, 32–38, 42–45
Drawing, 8, 10, 51
 contrapposto, 21
 from life, 20
 pencil, 28
 scanning a, 30
 See also Gesture drawing

E

Ears, 20, 23, 47
Ectoplasm, 119, 121
Emotion, expressing, 18, 22, 68
Eye, leading the, 34, 38, 46, 50, 58, 72, 84, 88, 90-91
Eyes, 17, 20, 22, 24, 115
 glowing, 104
 sunken, 111–113

F

Facial features, 20, 22–24
 See also under specific feature
Figures
 anchoring, 64
 building, 15, 18-27
 distorting, 47
 multiple, using, 68
 placing, 62, 76
Fingers, 25, 47, 77, 110–111
Fire, 40–41
 light, 64, 73, 83, 107
Fixatives, 8, 35
Flesh, rotting, 104–105
Fog, 44, 117, 124
Foreshortening, 88
Frankenstein, 24

Mary Shelley's, 72–75
 monster of, 66, 76–79

G

Gesture drawing, 18-19
 aggressive, 76
 arms, 80
 backward thrust, 19
 cowering and timid, 46
 crouching, 50, 84
 hands, 80, 110
 hunched, 62
 lumbering, 122
 lunging, 114
 lurching, 96
 of power and danger, 38
 reaching, 119
 swoop, romantic, 42
 tense, 72
 zigzag, 58
 See also Movement
Ghost, 118–121
Ghoul, 122–125
Glow, creating, 44, 104, 119
Goth vampire, 54–57
Graveyard, 50–53, 102–105

H

Hair, 89–90
 spiked, 62
Hands, 77, 99, 110–111
 constructing, 15, 25
 foreshortening, 88
Head, 14, 17, 20
 See also Facial features
Headless horseman, 114–117
Highlights, 16–17, 29, 31, 35, 64, 79
Hue, 13
 See also Colors

I

Inking, 8, 28, 30, 35, 47, 70

J

Jekyll and Hyde, 68–71
Joints, 15, 26–27

L

Layering
 color, 36
 digital, 5, 30
 textured, 31
Legs, 15, 27
Light
 fire, 64, 73, 83, 107

moon, 59, 86, 91, 107, 115-117
reflected, 16, 29, 64, 94, 103
temperature, 12, 29, 31, 41, 86
Lighting
day, 28
nighttime, 28, 52
rim, 44, 59, 86
sources, locating, 16–17, 35, 39, 44, 47, 51, 63, 69, 97
strong, 47, 73
under, 103, 120
Line, 47, 51, 71, 103
Lips, 20, 23–24
in rigor mortis, 102, 111

M
Materials, 7
drawing, 8
painting, 9–10
See also Adobe Photoshop
Mausoleum, 122
Metal, 61, 79
Modeling, 31
Monsters, 66–99
Frankenstein, 66, 76–79
Frankenstein, Mary Shelley's, 24, 72–75
Jekyll and Hyde, 68–71
swamp creature, 96–99
werebat, 92–95
werewolf, 88–91
witch, 80–83
wolfman, 84–87
Mood, color, 34
Moon, 44, 58, 60
as a compositional device, 50, 84-85, 88, 92, 114, 102
See also Light, moon
Mouth, 20, 23–24
Movement, 18
arm, 15, 26, 80
forward, 34, 42, 62, 76–77, 79, 102
leg, 15
running, 88
torso, 21
See also Gesture drawing
Mummy, 110–113
Muscles, 21, 26–27, 123

N
Nighttime, 28, 52
Nose, 20, 22, 24, 37
Nosferatu, 33, 46–49

P
Paint, 9, 13

Painting, 7, 9–10, 28–29
Palettes, 10
Paper, 8, 90, 112
Punk vampire, 62–65

R
Revision, 45, 56, 61, 116–117

S
Sarcophagus, 110–111
Saturation, color, 13
Scales, 97
Scumbling, 97–98
Shading, 15–17
Shadows, 28
placing, 16–17
structuring, 40, 115
Shapes, 14–15, 17
shading, 16–17
Sketches, thumbnail, 68, 118
transferring, 73
Skin, 44, 78, 112
dead, 74
highlights, 61
Software, 5
See also Adobe Photoshop
Spattering, 70
Stone, 44, 48, 76–77
Subtraction technique, 31, 105, 124–125
Surfaces, 10
paper, 8, 90
Swamp creature, 96–99

T
Teeth, 23, 47
Temperature, 12, 29, 31
color, 12, 29, 31, 41, 78, 91
Tension, 21, 29, 34, 76
Texture, 70–71, 77
digital, 42–43
inked, 48
monstery, 97
stone, 44, 48, 76–77
Tone, 13, 16, 28
sepia, 8, 28, 40, 120
See also Values

U
Undead, the, 100–125
ghost, 118–121
ghoul, 122–125
headless horseman, 114–117
mummy, 110–113
zombie, 24, 101–105
zombie pirate, 100, 106–109

Undertone, 30

V
Values, 13, 36, 44
See also Tone
Vampires, 24, 32–65
Dracula, 32–38, 42–45
goth, 54–57
kid, 50–53
Nosferatu, 33, 46–49
punk, 62–65
vampyra, 58–61
Vlad the Impaler, 38–41
Vampyra, 58–61
Vlad the Impaler, 38–41

W
Washes
color, 9, 36
ink, 8, 28, 40, 120
Water, 97
See also Wet effect
Werebat, 92–95
Werewolf, 19, 88–91
Wet effect, 98, 103
Wings, bat, 58, 92–95
Witch, 80–83
Wolf, 23–24, 89
Wolfman, 24, 84–87

Z
Zombie, 24, 101–105
pirate, 100, 106–109